THE URBAN SKETCHING HANDBOOK

UNDERSTANDING LIGHT
Portraying Light Effects in On-Location Drawing and Painting

KATIE WOODWARD

About This Series

The Urban Sketching Handbook series takes you to places around the globe through the eyes and art of urban sketchers. Each book offers a bounty of lessons, tips, and techniques for sketching on location for anyone venturing to pick up a pencil and capture their world.

➲ **KATIE WOODWARD**
Michigan Avenue, Chicago, Illinois
4" x 6" | 10.2 x 15.2 cm; watercolor,
graphite pencil, Pigma Micron pens

CONTENTS

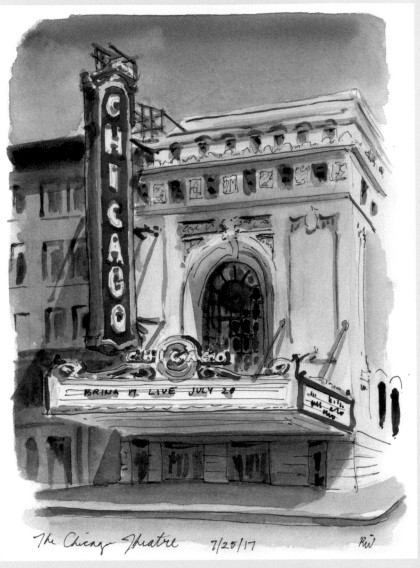

The Chicago Theatre 7/25/17 KW

🎧 **KATIE WOODWARD**

Chicago Theatre, Chicago, Illinois

6" x 8" | 15.2 x 20.3 cm; watercolor,
graphite pencil, white Uni-ball Signo gel pen

INTRODUCTION

There is light on everything we see. The color and quality of that light and how it interacts with our surroundings deeply affects our relationship with the world around us, and thus how we choose to portray it in our sketches. Learning how to accurately replicate different lighting circumstances can give sketches a better sense of realism. Mastering lighting can also help with decisions outside of reality, to help you sketch what you wish you saw, or manipulate the mood of a scene. Capturing the light can be a challenge; it often changes faster than we can sketch! Painting the sunlight dappled through a tree is hard enough without an inopportune cloud getting in the way.

I hope this book inspires you to try some new tips and tricks in your own work. The objective is to strengthen our observation skills and learn how to translate those onto the page. While urban sketches absolutely do not have to be realistic (and it would be boring if all of them were!), this book is more geared towards realism as we try to understand what the light in front of us is doing. The more we ask the question, "What do I see?" the more informed choices we can make about replicating it on the page, whether we are aiming for accuracy or decisively choosing to sketch what we wish were in front of us. Some of the most interesting sketches skew reality and make something new entirely. The secret lies in taking nothing in front of us for granted, not assuming we—know—what anything looks like, and taking the time to really see.

If you put two sketchers next to each other with the same materials, their sketches will never be identical. Every artist views a scene from a unique perspective and tells a story in their own way. Sharpening our observation skills gives us more options and opportunities in ways to tell that story. You are in charge of how you choose to record what you are seeing. You get to choose if you want to aim for an accurate portrayal of the light in front of you, or heighten the contrast or atmosphere, or make another choice. You get to choose how much you want to plan ahead or whether you just wing it! Sketches are guided by what our eyes focus on and what we choose to portray. Every sketch begins with an observation, a scene hits the eye and is filtered through a mind and a hand until it appears on the page as something a third party can view.

TOOLS

Before we can dive into the waters of understanding light, what tools do we use? Where do we begin?

Pencils, pens, pastel, and paints! There are so many tool options out there. For the urban sketcher, one thing is always the most important: portability. What do you want to carry with you? For some this may be a plein air easel with a full oil paint setup, for others it may be a ballpoint pen and a small sketchbook that can be stowed in a pocket. It requires some testing of materials to decide what you're interested in working with, and what you want to be troubled to drag along with you. Luckily, urban sketching is a perfect time to experiment with new things! You can experiment with however many materials you want, and you never have to pick just one.

When choosing your tools, think about how you'll be using them out in the world. Do you need to bring a small stool to sit on? How will you balance everything? Do you need a board to clip materials to? Something to keep your water from spilling? What type of case or pouch do you need hold everything when your tools aren't in use? Figuring out your setup is just as important as the tools themselves. Time spent figuring it out at home is time saved when you are starting to sketch on-site. Remembering to include things like sunscreen and a big hat to keep the sun out of your eyes can improve your sketching experience.

- sketchboard
- water cup
- 0.3 mechanical pencil
- assorted Pigma Micron pens
- watercolor brushes
- portable watercolor palette
- portable stool
- binder clips
- folder with loose watercolor paper
- battery-powered clip light (for nighttime sketches and dark museums)

KEY TERMS

The following vocabulary is used throughout the book and can be useful for talking about light in our sketches.

Cast Shadow: The shadow of one object falling on another object.

Chroma: How much saturation a color has. A high-chroma color will be vibrant and saturated with pigment, while a low-chroma color will be more neutral (more gray or brown). The stripe starts by being a high-chroma orange, and by mixing with its complement, a blue, it becomes a low-chroma brown.

Complementary Colors: Colors that appear across from each other on the color wheel (red and green, blue and orange, purple and yellow). Mixing these together can make browns and grays.

Contrast: The difference between two or more elements. Black and white are an example of high contrast, while similar tones would be lower in contrast.

Form Shadow: A shadow created by the object itself blocking the light.

Highlight: The area where the most light hits an object.

Hue: Another word for color.

Local Color: The color of an object as it appears in bright, colorless light.

Occlusion Shadow: A shadow that falls in the tiny nook between two objects that are close together.

Reflected Light: When light bounces off one object and hits another, often filling in a shadow.

Value: How light or dark something is.

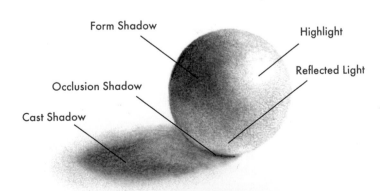

Form Shadow

Highlight

Reflected Light

Occlusion Shadow

Cast Shadow

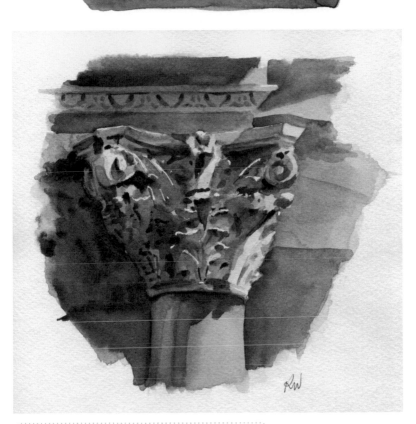

Starting a Sketch

All sketchers have their own process. When starting a sketch, I like to begin by blocking in the biggest shapes because it's the only way I can manage to keep a subject on the page without running out of space! Whether you start with the biggest shape, work from one side of the page to the other, go straight to paint, or meticulously plan in graphite, the most important thing is to begin. Don't worry so much about how it will turn out or messing up; remember, it's just sketching and should be fun. If you aren't happy with the results, you can always try again. We learn something with every sketch, regardless of the outcome.

⌂ KATIE WOODWARD
Column Capital,
New York City

8" x 8" | 20.3 x 20.3 cm;
graphite pencil, watercolor,
white Signo gel pen

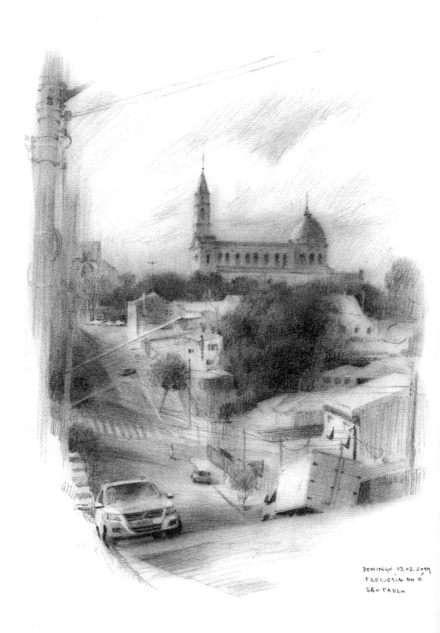

DOMINGO 03.02.2019
FREGUESIA DO Ó
SÃO PAULO

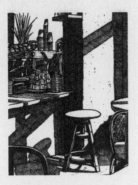

KEY I
VALUE

To understand lighting, we must first look at value. While color can add a lot to a sketch, value will always be the backbone. Value helps provide structure and often is the base of a composition. By studying value, we can better grasp where light is coming from and how to work with shadows before adding the complexity of working with color. There is a lot to learn from working in monotone and exploring how light affects value. Although color can add an extra layer of depth and understanding to a sketch (more on that next chapter), even a color sketch is going to rely heavily on value to convey the idea of light. When considering value, we must observe where the light is coming from and where it is being obstructed, creating shadows.

☾ **EDUARDO BAJZEK**
Freguesia do Ó, Sao Paulo, Brazil
11" x 8½" | 28 x 21 cm; Cretacolor Nero Pencil,
soft and medium; 1 ½ hours

FIND THE LIGHT

When we start any sketch, we should think about where our light is coming from. When it comes to value, it's good to specifically look for the shadows on and around our subject. Often when direct light hits an object, it naturally creates very light lights and dark darks. Because the eye is drawn to places of high contrast, sketchers can use this to their advantage when considering composition.

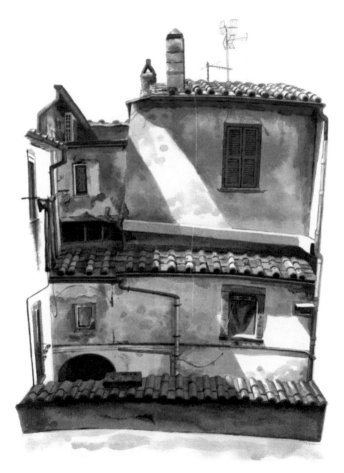

⋂ FRED LYNCH

The Hot Apartment, Viterbo, Italy

15" x 11" | 38.1 x 27.9 cm; brown ink and pencil in sketchbook; 4 hours

Look at how the dash of sun streaking across the building moves the eye, and the shadows between the roof tiles draw the eye around.

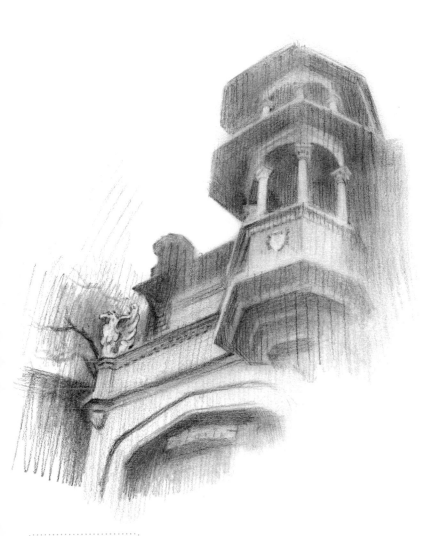

⋂ EDUARDO BAJZEK
Parque Savoia, Sao Paulo, Brazil

*11" x 8⅓" | 28 x 21 cm; 3B to 6B Koh-I-Noor;
45 minutes*

See how the eye is drawn to the line of the
darkened overhang of the roofline meeting
the white sky, and the light columns against
the shadow beyond.

Light and Perception

When working on any sketch, it's good to remember that the presentation of certain elements changes our perception of them. If a sketch is very dark, the "light" area may be a darker midtone. It's even possible for something to appear "white," when in reality it's much darker, just because the eye compares it to its surroundings. When a sketch is very light overall, shadows may just be a whisper of graphite. Breaking down the elements as you work and considering how they relate to each other can help to create a more cohesive sketch. Instead of just looking at how dark the shadow is in your sketch, consider how dark it is compared to other parts of the sketch. When you look back at the two parts in the actual scene, is the difference about the same? While you can get a good approximation of a scene by looking to imitate each piece on its own, more harmony can be found by connecting the elements and approaching them as a whole. This technique can also help you figure out what looks "off" about a sketch without having to guess by changing elements one by one to see what looks better or worse.

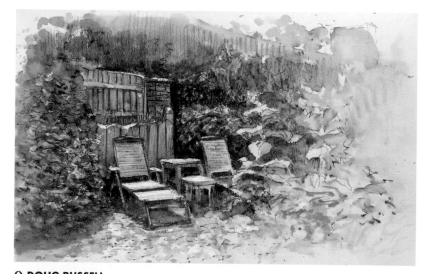

⋂ DOUG RUSSELL
Backyard Study, Laramie, Wyoming
*7½" x 11" | 19 x 27.9 cm; Prismacolor pencil
on pearl gray Stonehenge paper; 1 hour*

To consider light in a sketch, start by finding and defining your light sources. Understanding light can be boiled down to finding and following the pathways of light, from their source to the appearance of shadows. Sketchers should also remember the quality of light provided by direct sunlight, indirect sunlight, fluorescent and incandescent lamps is different and can help inform your choices moving forward.

Bright, direct sunlight can be clear and blinding, coming from one direction and causing a defined shadow. Indirect sunlight tends to be softer, causing lighter shadows with fuzzy edges, or on an especially overcast day, practically no shadow at all. Fluorescent light can behave similarly to an overcast day, with very little shadow, causing subjects to look flatter. Incandescent lamps can behave similarly to bright sunlight, but on a smaller scale.

Observation Checklist

❏ Find every light source in your view, whether it's the sun, streetlights, or light escaping a window or open door.

❏ Do you see defined shadows? (Look at where the light is coming from and check the opposite side of any buildings or objects in your view).

❏ What does the edge of the shadow look like? Soft or hard?

❏ Find the brightest thing in your view, and the darkest.

❏ Do you see any highlights where bright light is hitting an object?

↻ YEVHENII OMETSYNKSYI
Ikea Ladder, Kyiv, Ukraine
2¾" x 2½" | 7 x 6.5 cm; liner,
Sakura Coloring brush pens; 45 minutes

Tip

Squint your eyes to better see the contrast between objects; it will make it easier to spot the brightest lights and darkest darks.

EXPLORING CAST SHADOWS

Often when we're thinking about lighting in a sketch, one of the
first things that comes to mind are cast shadows. These are the
dramatic shadows that happen when an object blocks the light,
and we can see the shadow on the ground or a nearby object.
The shape of the shadow will mimic the shape of the object
itself, though often truncated or stretched, depending on how
the light is hitting it. Perhaps the shadow is also taking the shape
of the surface it is hitting, folding around door frames or rippling
over uneven terrain.

How dark your cast shadows are can depend on the quality
of light hitting the object. Experiment in your sketches with using
cast shadows of differing values.

↻ YEVHENII OMETSYNKSYI
Apples, Kyiv, Ukraine
3¾" x 5⅛" | 9.5 x 13 cm; liner; 1 hour

◯ YEVHENII OMETSYNKSYI
Work Desk, Kyiv, Ukraine

3 ½" x 4⅛" | 8.5 x 10.5 cm; liner,
Sakura Coloring brush pens; 1 hour

Gallery: Cast Shadows

⋒ PEDRO ALVES
Duque de Cadaval Square,
Lisbon, Portugal

13¾" x 6" | 35 x 15 cm;
ink and watercolor; 30 minutes

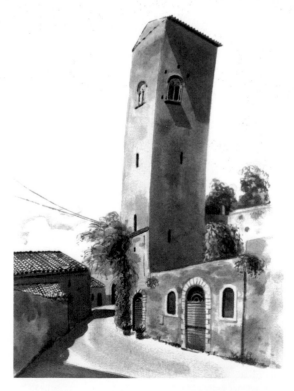

◔ FRED LYNCH
Templar Tower, Viterbo, Italy

11" x 7" | 27.9 x 17.8 cm;
brown ink and pencil; 4 hours

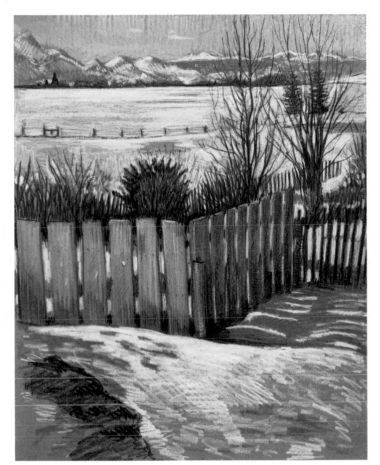

↷ DOUG RUSSELL
View of the Big Horn Mountains, Banner, Wyoming

14½" x 11½" | 36.8 x 29.2 cm; Prismacolor pencil on brown Stonehenge paper; 2 hours

Cast shadows can occur on the ground right next to an object, scraping down the façade of a building, or anywhere something obstructs the path of light. The shadow will form around the shape of the surface it is hitting; it may conform to rolling hills or fold itself around a door casing. Considering both the shape of the object that casts the shadow and the shape and surface of the object that shadow hits can give you clues on how you may want to render it. A shadow falling over uneven ground, for example, should follow the shape of the terrain. In the sketch above, you can see that the shadow of the fence, which normally would be very linear, follows the hills and valleys of the ground, while still including the slices of light in between shadow that give us clues on the shape of the fence itself.

MERGING SHADOW SHAPES

As we approach a view to sketch, the mind can jump to thinking of each individual object as its own shape. But, when we focus on lighting, we can ignore the imaginary lines surrounding each object. Often, shadows can continue from one object to the next, creating new shapes that visually merge objects together. You can decide for yourself if you want to separate those merged shapes in your sketch!

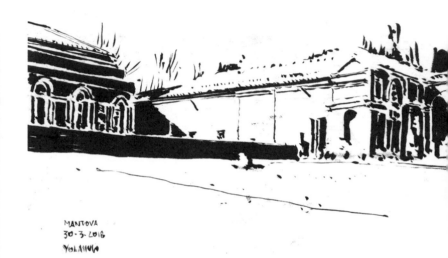

MANTOVA
30·3·2018
YOLANDA

Tip

Whenever overwhelmed by a complex view, consider ways you can simplify it. Maybe that means using fewer colors, only two values, or focusing in on a small section of the view.

Sometimes when playing with value, it can be easy to get caught up in the large range of shades you see before you. However, it is possible to depict a full scene just using white and one shade for everything dark! This means nothing is shown as a medium value: everything gets sorted into either light or dark. Even the most complex subjects can be simplified. Choose which shadows can be merged together, and what must be separated to make the subject recognizable.

☾ HUGO COSTA
Palazzo Te, Mantua, Italy
8¼" x 11¾" | 21 x 29.7 cm; brush pen;
15 minutes

☽ HUGO COSTA
Campo dei Mori, Venice, Italy
4" x 16½" | 10.5 x 42 cm; brush pen,
35 minutes

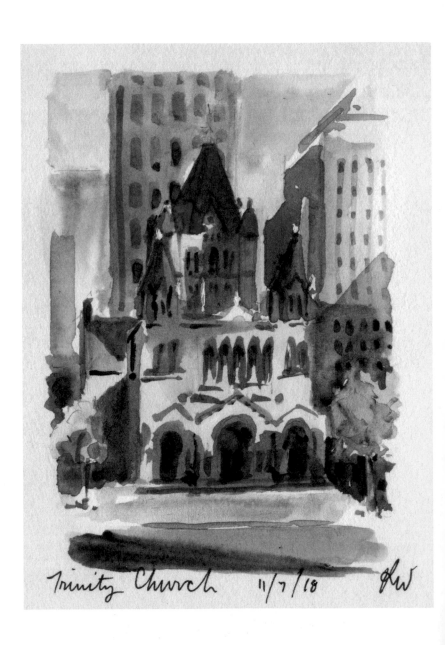

Trinity Church 11/7/18

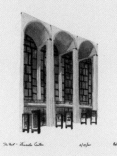

KEY II
COLOR

Color can greatly affect a sketch. When utilized well, you can make a viewer feel the warmth of the sun, or the chill of rain. Color can be the easiest way to give a sketch a sense of realism or it can be a fun way to make a creative departure from what is in front of you. As with any part of a sketch, color comes down to artist's choice. Every urban sketcher has their favorite pigments and learns how to make those work for them. To really embrace a lighting scheme, the trick isn't in the specific colors you use, but in how the colors you use relate to each other and in how you choose to employ them.

☾ KATIE WOODWARD
Trinity Church, Boston, Massachusetts
3" x 4" | 7.6 x 10.2 cm; watercolor, pencil, and pen

LOCAL COLOR

As artists, we can choose how much to rely on local color. Local color is the hue of an object as it appears in full white light, but the color and direction of lighting shifts the appearance of the color of an object. Because of the many lighting changes throughout the day, when it comes to seeing a piece of art, our eye tends to believe what it takes in as real. Our minds find a wide variety of color choices believable. If we paint everything only its true local color, we will likely end up with a cartoonish, flat approximation of the scene. To add dimension, atmosphere, and mood, we need to take into account the lighting conditions.

Tip

Try using a limited palette when dipping a toe into starting with color. Start by just observing colors as warm and cool. A yellow and a purple can be great for this purpose.

Overcast

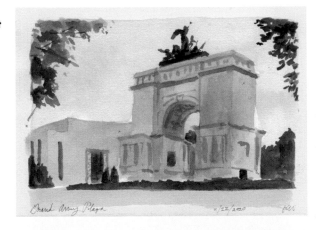

Backlit

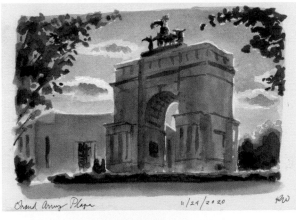

Late afternoon

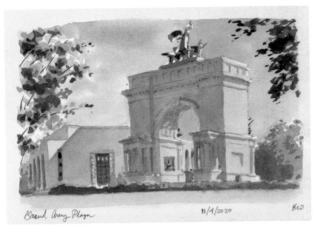

Sunset

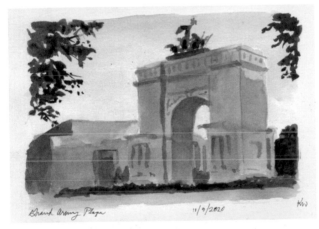

Night

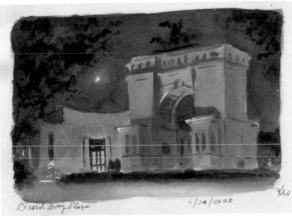

⊂ The local color of the structures in this scene hasn't changed, only the lighting.

ALL:
KATIE WOODWARD
Grand Army Plaza, Brooklyn, New York

5" x 7" | 12.7 x 17.8 cm; watercolor, pencil, and pen

LIMITED PALETTES

When beginning to use color, consider: Is the color you are observing warm or cool? That doesn't mean it must be a bright orange or blue, but instead try to decipher the warmest and coolest parts of a subject. This is easiest to observe on a white- or cream-colored architectural detail (like a statue or column capital), which make excellent practice subjects before advancing to something with more complicated local color. As discussed in the value section, it is important to look at everything in relation to each other. You may choose to make shadows that are perceived as cool a little more blue or purple than in reality. It can be a great jumping off point to help simplify a view, and a way to transition into really deciphering each individual color.

Broken Shadows 3/18/20

⋔ KATIE WOODWARD
Brooklyn Shadows, Brooklyn, New York
4" x 4" | 10.2 x 10.2 cm; watercolor, graphite pencil, white Signo gel pen; 35 minutes

To be the best possible observers, we need to somewhat ignore local color and what we believe the color of an object to be in order to determine what is really there. Leaves may be green, but not just any green will do. And if we observe those leaves at night, they may not be green at all! Try to zero in on the color you are really seeing, and not just what you expect to see. We may know a street sign is red with white letters, but perhaps in shadow it appears as a deep purple with lavender letters. Sketching is learning to listen to your eyes, rather than your brain.

◠ VIRGINIA HEIN
Front Porch Thumbnail
Cars in Two Colors,
Los Angeles, California

5" x 5" | 12.7 x 12.7 cm; graphite pencil, watercolor, and gouache; 30 minutes (as a part of a larger page of thumbnails)

Sketching with Mud

Color is relative. In a sketch with a lot of orange, a cool grey may appear very blue by comparison. That same grey may appear warm if placed next to a cerulean blue. Sketchers often worry about their sketches becoming "too muddy," but sometimes we can use mud to our advantage. In truth, many of my favorite paints are a little dull, which gives me faster mixing since I so rarely want full, pure colors. Want to make a red awning stand out? Turn down the chroma of the colors around it! Decide when a subject needs pure color, and when to dilute it. Even in neutral "mud" there is great variety to be had in terms of both color temperature and value

When choosing colors to include in your palette, see what neutrals they mix into. Paints that give you a wide array of attractive grays and browns may be appealing for the variety they can provide. A pigment that looks great on its own but doesn't play well with others may not be worth keeping in your palette. On the other side of the coin, you can choose to make colors more saturated (higher chroma) and vibrant than they are in reality. Both of these are great options, and it comes down to artist's choice.

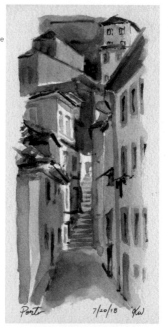

⊃ **KATIE WOODWARD**
Porto Stairs, Porto, Portugal
4" x 8" | 10.2 x 20.3 cm; graphite pencil, watercolor, white Signo gel pen; 30 minutes

Tip

Experiment by sketching the same scene in two ways: one trying to use the most vibrant colors possible, and the next by using mud made on your palette from the first sketch.

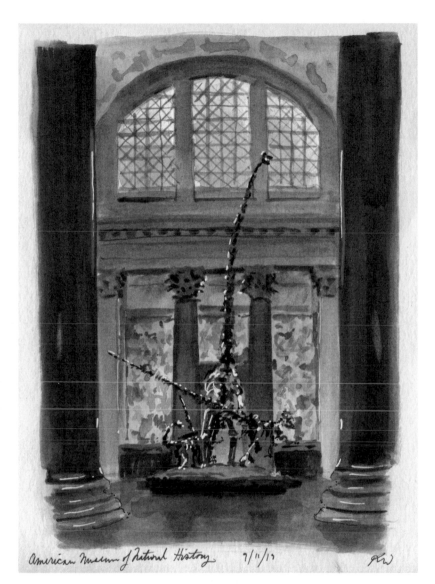

American Museum of Natural History 9/11/17

☊ **KATIE WOODWARD**
American Museum of Natural History,
New York City

6" x 8" | 15.2 x 20.3 cm; graphite pencil,
watercolor, Pigma Micron pens,
white Signo gel pen; 1 ½ hours

CAST SHADOWS IN COLOR

When approaching cast shadows in color, look at everything the shadow touches. A single shadow may be cast over the ground, the wall of a building, cars on the road, trees and more, all of which have their own unique local color. You may choose to stick to one shadow color for the full shadow, or break it into pieces and mix a separate color to account for each object's local color differently.

⊃ KATIE WOODWARD
Village Cigars,
New York City

*3" x 4" | 7.6 x 10.2 cm;
watercolor, graphite pencil, white
Signo gel pen; 40 minutes*

◔ PEDRO ALVES
Paz Street,
Torres Vedras, Portugal

*11¾" x 8" | 30 x 20 cm; pencil
and watercolor; 1½ hours*

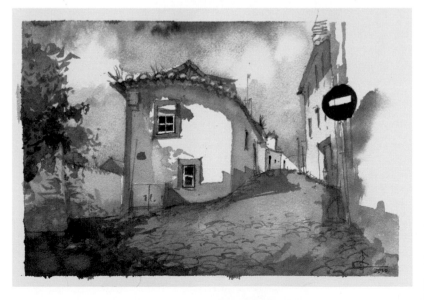

When working in a transparent medium like watercolor, it's possible to do a sweeping shadow across everything with a cast shadow, although you have to consider how the shadow color will interact with the colors you already have down. When working in an opaque medium, you often have to pick shadow colors separately to keep detail and information in the shadow. Otherwise you risk the shadow being a flat shape, overwhelming the sketch, and not reading like a shadow at all.

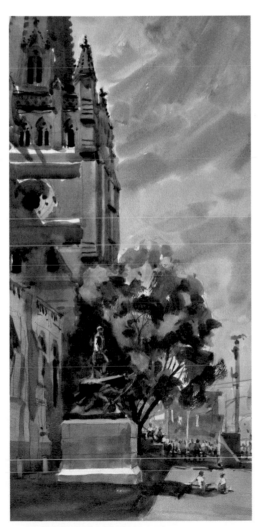

☾ MIKE KOWALSKI
Flinders Statue in Shade,
Melbourne, Australia

16" x 8" | 40.6 x 20.3 cm; watercolor; 45 minutes

See all the different colors the shadow takes on as it covers different surfaces.

Gallery: Cast Shadows in Color

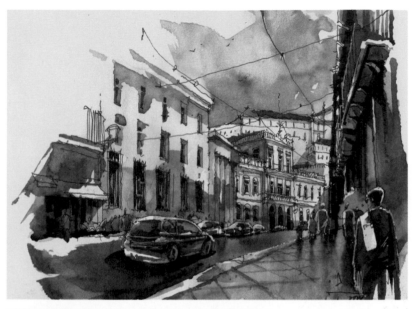

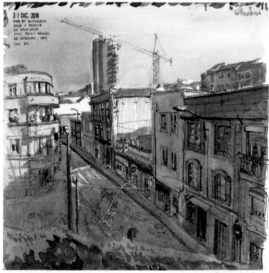

∩ PEDRO ALVES
Sofia Street,
Coimbra, Portugal
11¾" x 8" | 30 x 20 cm;
ink and watercolor; 1 hour

Here, on one side of the street we have the shadow side of a row of buildings, and we can see the shadow they are casting on the street and the buildings opposite them. Blues cover everything in that cast shadow, while darker pigments add details within the shadow.

∩ HUGO COSTA
Rua do Bonjardim, Porto, Portugal
8½" x 8½" | 21 x 21 cm; fountain pen and watercolor; 2½ hours

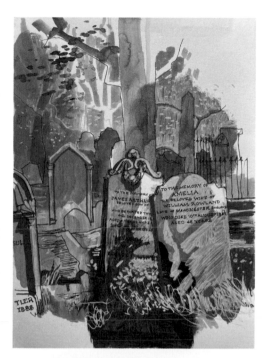

☾ ALEX SNELLGROVE
Graveyard,
Newtown, Australia

8¼" x 11¾" | 21 x 29.8 cm (A4); markers (Posca, Tombow, Fineliner) on a prepared, multicolor acrylic background (not made specifically for this purpose); 45 minutes

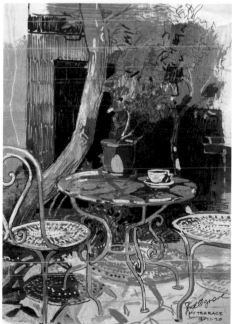

☾ ALEX SNELLGROVE
On My Terrace,
Randwick, Australia

8¼" x 11¾" | 21 x 29.8 cm (A4); markers (Posca, Tombow, Fineliner, Faber Castell) on a prepared acrylic background; 1½ hours

Just because you use aspects of realism doesn't mean you need to aim for a photorealistic sketch. You can pick and choose what you want to portray, in the same way you may leave out cars and people, or add them in. Alex Snellgrove always takes lighting into account but uses wild colors.

REFLECTED LIGHT

Explore how much color and detail can be found in shadows! Bright light tends to blow out highlights, making it difficult to see as much detail because it is obscured by blinding light. It is totally acceptable to omit them even if you know they are there. Instead, try paying more attention to the shadows. Adding color, detail, and depth to those helps the eye fill in anything omitted in the highlights. Skip black shadows and reach instead for a blue or purple. Upward facing shadows, like those on the ground, are often cooler when reflecting blue sky. Sometimes light can bounce off one surface and reflect back at another, which can change the color of your shadows. Downward facing shadows, like the underside of a balcony, may be hit with light from the ground or another object, making shadows appear warmer. Using this light to your advantage can give a sketch a nice glow. Look at the cast shadows in these sketches, and how they change in color. This isn't paint-by-number, nothing has to be a solid hue! Adding variations and gradients can bring life and realism to a sketch. Flattening the highlights and adding more color and detail to shadows will change the quality of light in a sketch.

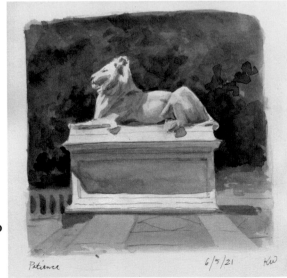

⊃ KATIE WOODWARD
New York Public Library Lion, New York City
6" x 6" | 15.2 x 15.2 cm; watercolor, graphite pencil

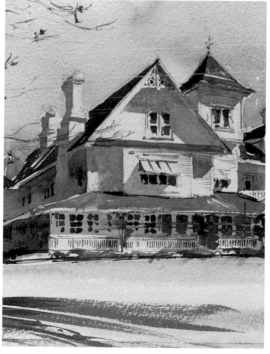

⋂ FRED LYNCH
Pawcatuck House,
Stonington, Connecticut

8" x 10" | 20.3 x 25.4 cm;
brown ink and pencil; 4 hours

See here in value how the far
corner of the house is lit by the
light bouncing off the street?
Without that reflected light, it
would be in darker shade!

☾ ALEX HILLKURTZ
California Light,
Nicasio, California

8" x 8" | 20 x 20 cm;
ink and watercolor; 2 hours

Gallery: Reflected Light

⌒ ALEX HILLKURTZ
Café Charisse, Paris

*15¾" x 11¾" | 40 x 30 cm;
ink and watercolor; 2 hours*

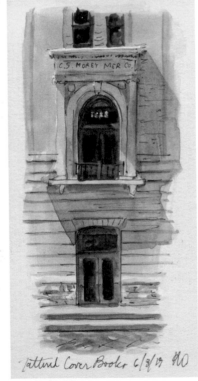

⟳ KATIE WOODWARD
*Tattered Cover Books,
Denver, Colorado*

*3" x 6" | 7.6 x 15.2 cm;
watercolor, graphite pencil,
brown Pigma Micron pen,
white Uni-ball Signo gel pen;
30 minutes*

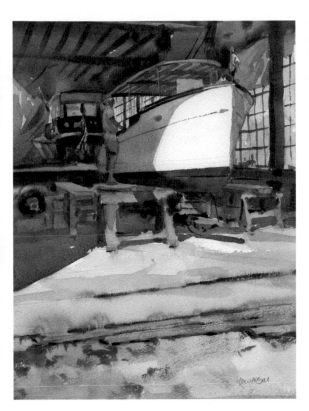

☞ MIKE KOWALSKI
Spanish Cedar,
Oxford, Maryland

12" x 9" | 30.5 x 22.9 cm;
watercolor; 1½ hours

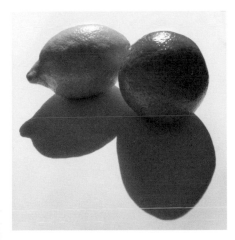

Objects with bright colors can also reflect light onto one another. Perhaps a brightly colored awning reflects its red hue onto the wall above it. Reflected light can appear in or out of shadow, though bright light can obscure it, so it may be most pronounced in shadows that are being filled with the color of the reflected light. As in this photo of a lemon and a tangerine, you can see yellow and orange reflected in the edges of cast shadow closest to the fruit. You can also see the orange of the tangerine reflected in the surface of the lemon, where they touch. These types of reflected light can happen on matte surfaces as well, but since the fruit is shiny, we also get additional highlights on top from the light source and interspersed in the shadow side of each fruit where the white table is reflected.

SCULPTING A SKETCH WITH SHADOW

Shadows can help sculpt a building or object and allow it to appear more three-dimensional, giving volume to the objects we sketch and helping them jump off the page. This is easiest to observe in bright, directional lighting on buildings. Often, each side of the building is a slightly different shade. Or, perhaps, if the light is bright enough, a corner may disappear, and we are left with the darkest shadow to inform the shape of the building.

⊃ **KATIE WOODWARD**
San Remo,
New York City
3" x 4" | 7.6 x 10.2 cm;
watercolor, graphite pencil

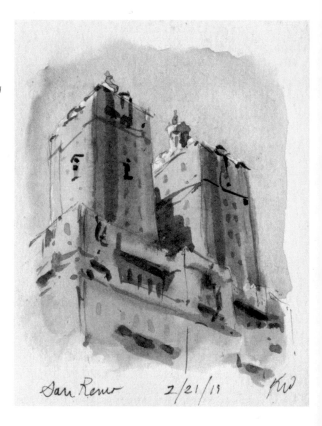

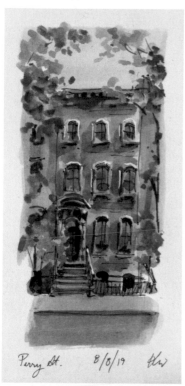

Perry Æt. 8/8/19 Kw

☾ KATIE WOODWARD
Perry Street, New York City

3" x 6" | 7.6 x 15.2 cm; watercolor, graphite pencil, white Uni-Ball Signo gel pen

On a smaller scale, you can still consider highlight and shadow as sculpting tools. Here, the highlight on the top edge of each window casing coupled with shadow below makes the architecture of each window pop off the page and appear more three-dimensional.

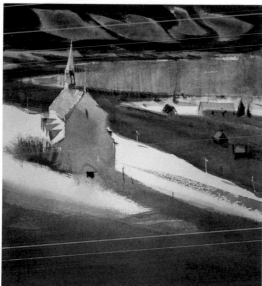

☾ BHUPINDER SINGH
Lebret Spring, Saskatchewan, Canada

9" x 10" | 22.9 x 25.4 cm; graphite pencil, watercolor; 1½ hours

Here, the side of the church and the shadow it casts blend together into one color, while the light side of the church informs the shape of the building.

Gallery: Sculpting a Sketch with Shadow

⊃ BHUPINDER SINGH
Cloudy Viceroy SK,
Saskatchewan, Canada

*10" x 14" | 25.4 x 35.6 cm;
watercolors, pencil; 2 hours*

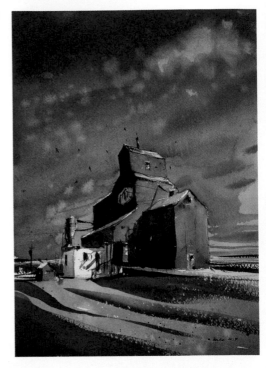

ʊ TINA KOYAMA
Legislative Assembly Building,
Victoria, B.C., Canada

*5½" x 8½" | 14 x 21.6 cm; water
soluble colored pencils; 1 hour*

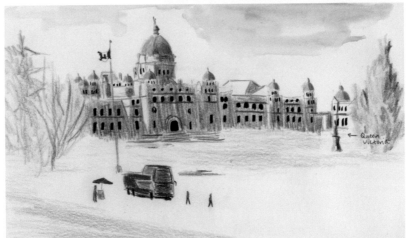

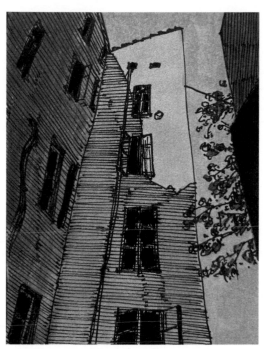

☾ **YEVHENII OMETSYNKSYI**
Budapest Fragments,
Budapest, Hungary

3½" x 2¾" | 9 x 7 cm; liner, watercolor

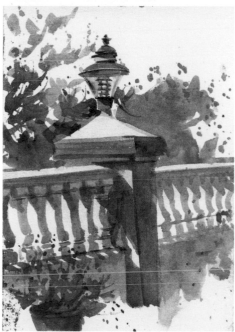

☾ **ANITA ALVARES BHATIA**
Morning Sun, Mumbai, India

8¼" x 5¾" | 21 x 14.7 cm; watercolor;
1 hour

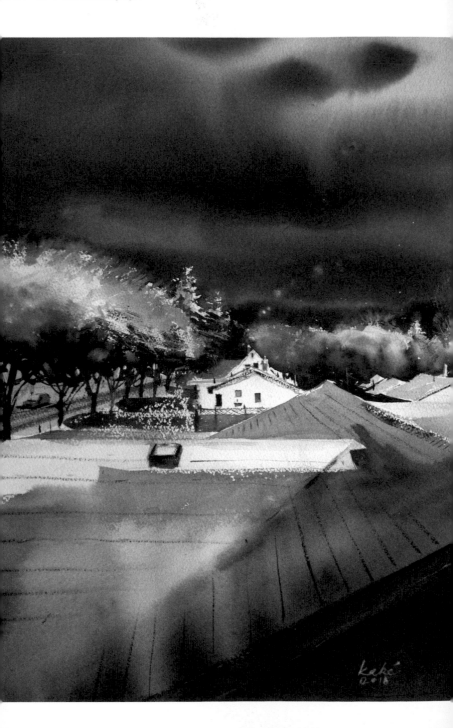

KEY III
SKIES AND ATMOSPHERE

We have all seen work that has an incredible sense of atmosphere. Maybe it feels like the subject is glowing or encased in fog. The mood of a sketch can be even more captivating than the subject. Before we can create such a work, we must explore what give us that feeling in work when we see it. Is it the changes in value? The color choices? The mix of soft and hard edges? The dramatic clouds? This section explores some specific lighting circumstances that can give any sketch a "wow" factor.

C BHUPINDER SINGH
December Frost,
Saskatchewan, Canada
15" x 22" | 38.1 x 55.9 cm;
watercolors, pencil, white gouache;
3 hours

ATMOSPHERIC PERSPECTIVE

Atmospheric perspective is the effect the atmosphere has on subjects viewed from a distance. This can be best observed on far-off mountains or hills, or in layers of buildings in a skyline. Often far-off objects become lighter and similar in color to the sky, while closer objects remain their true local color and value. As sketchers, we can use this to our advantage not only by replicating it when we see it, but by including it when we don't. You can use this gradation to help create depth in a sketch, whether objects are separated from one another by miles or by inches. By making the choice to keep objects closer to you a little warmer and ones farther away cooler (or vice versa), it helps the eye move back through the sketch and separate out elements that otherwise would have the same local color. If you aren't working in color, just make the far-off subject lighter in value. This shift in value is helpful when working in color as well. Give it a try!

Tip

When looking at layers of hills or buildings, look at the one closest to you and the one farthest away. These are the two ends of the spectrum of gradation you will be seeing, so it will be the easiest to tell the difference between these two.

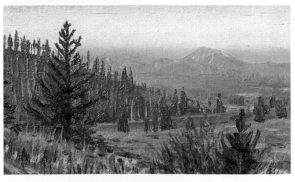

↺ **REMINGTON ROBINSON**
Sunrise Over Byers Peak,
Grand County, Colorado

1⅞" x 2⅛" | 4.64 x 7.64 cm;
oil on wood panel

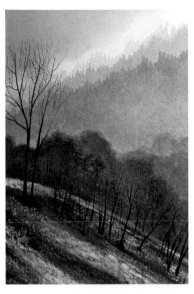

> **Tip**
> Try using atmospheric perspective to separate foliage. It is an easy way to help separate out groups of trees and create depth among so much green.

↻ DAVID LOWTHER
Trees at Fernilee, Derbyshire, United Kingdom
8" x 11" | 20.3 x 27.9 cm; gouache and pastel

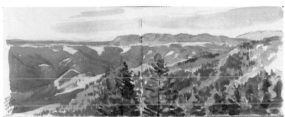

↻ MIKE KOWALSKI
Hell's Canyon Dawn,
Wallowa County, Oregon
7" x 20" | 17.8 x 50.8 cm;
Pentalic watercolor sketchbook
and watercolor; 45 minutes

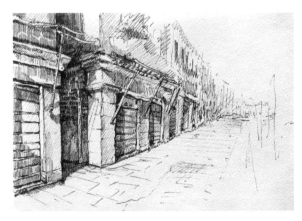

↻ DOUG RUSSELL
Cannaregio, Venice, Italy
8" x 11½" | Black Copic
Multiliner pen in a Moleskine
watercolor sketchbook;
45 minutes

Atmospheric perspective can mean a color and value shift as objects recede into the distance, but you can also consider keeping the foreground higher in contrast. You may also blur edges as they recede. All of these techniques can be used to both show atmosphere and to direct the viewer's eye to what you want them to focus on.

FOG

When urban sketchers think about air affecting our sketches, it's usually in terms of temperature or humidity: "how fast will my paint dry?" But there are other ways air can affect our work! Is there dust, pollen, or smoke in the air? These elements can change a scene and add a level of drama to a view, and our sketches.

When looking at a scene, pay attention to where objects and elements meet. Whenever any particles are hanging in the air, light bounces off and things can seem a little hazier; edges may appear softer, the color of the subject may be a little grayer. An extreme example of this is fog, which can fully obscure parts of your view. Look how the fog in this sketch from Porto hides the bridge: you may see hints of it through the fog, but the edges aren't defined. As shapes emerge from the fog, the edges become sharper and more clear. By taking these things into account as we sketch, it can transport the viewer, giving them a better sense of the conditions the artist was experiencing, which helps define the mood of a sketch.

⊃ KATIE WOODWARD
Porto Fog, Porto, Portugal
4" x 6" | 10.2 x 15.2 cm;
watercolor and graphite pencil

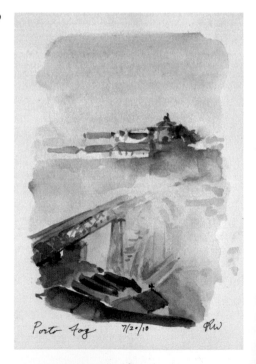

☾ KATIE WOODWARD
Big Sur, Big Sur, California
6" x 6" | 15.2 x 15.2 cm;
watercolor and graphite pencil

Similarly, in this sketch you can see the fog encroaching from the left side, obscuring the hill behind it. By generally softening the edges and reducing contrast, it gives the impression of a gray, misty day, rather than one with bright sunlight.

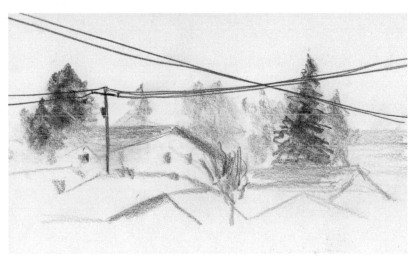

☊ TINA KOYAMA
Foggy Christmas Morning, Seattle, Washington
5½" x 8½" | 14 x 21.6 cm; graphite pencil; 10 minutes

USING SOFT EDGES

Pay attention to your edges—are they hard or soft? Where two objects meet, which is darker? Even if there is no fog, you can still experiment with using soft edges to convey atmosphere and mood. Try softening edges in your work to play with effects. You can soften your edges in any medium; in watercolor this may mean adding water over the corner of a recently finished shape, in graphite it may mean smudging an edge.

○ TINE KLEIN
The Reading Room,
Basel, Switzerland

12" x 16⅓" | 30.8 x 41.3 cm; graphite powder, pencil, kneaded eraser, masking tape, fingers; 20 minutes (plus 20 minutes to clean up the graphite powder)

This sketch uses soft edges to conjure bright light in a dusty reading room.

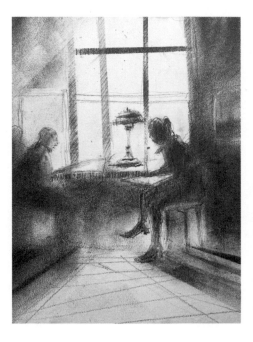

"I discovered the room and started a quick simple pen sketch. But that was not what I wanted. I wanted to sketch the light. That is why I started to use graphite powder. The sketch was nearly finished in 10 minutes and another 10 minutes for modelling the light into the right mud. Happily, I sketched with my fingers. But then I was dirty like an urchin. I needed the same time, about 20 minutes, to clean myself and the table discreetly without creating a scandal."
—Tine Klein

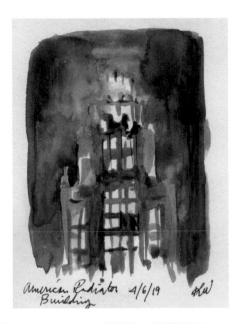

☾ **KATIE WOODWARD**
American Radiator Building,
New York City

3" x 4" | 7.6 x 10.2 cm;
watercolor, graphite pencil;
30 minutes

OVERCAST DAYS

On overcast days, shadows are practically nonexistent. The view before us has less contrast and everything flattens. You may still see atmospheric perspective and reflections, but shadows and reflected light won't be as prominent, if visible at all. This can be a great time to practice imagining light on an object or taking advantage of the consistent lighting to really get invested in architectural details.

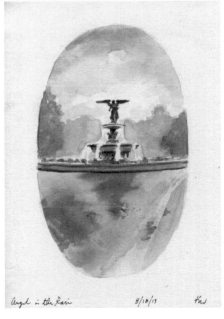

☾ **KATIE WOODWARD**
Angel in the Rain,
Central Park, New York City

5" x 7" | 12.7 x 17.8 cm;
watercolor, graphite pencil;
30 minutes

CLOUDS

Let's talk about an important part of many skies: clouds! Whether big, fluffy cumulus clouds or wispy cirrus, clouds can add interest and gravitas to the skies of your sketches. It is worth noting that although clouds may appear as large, flat white shapes in the sky, they are three-dimensional. They can (and often do) have shadow. As they are composed of water droplets, and, depending on their density, some may be more translucent. Light on any translucent object (human skin, foliage, etc.) will behave less predictably than it will on an opaque, matte surface, so it is important to come back to observation.

Because clouds are hanging way up in the air, the sunlight will be hitting them differently than it hits buildings and objects on the ground. During sunset and sunrise, for example, it is not uncommon for clouds to have shadows on their tops, while the undersides may be a glowing orange or pink color (sometimes silhouetted on a still-blue sky.). At noon, clouds overhead may be backlit by midday sun. You may see them being harshly backlit, with edge lighting all around but with darker middles. As with atmospheric perspective, you may find that clouds in the distance, closer to the horizon, start to blend into the sky while the ones closer stand out and have more contrast. We tend to fall into the

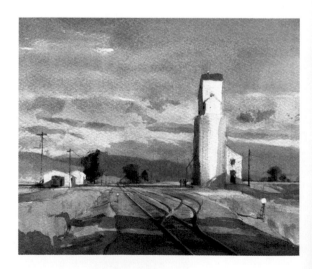

◗ **MIKE KOWALSKI**
State Line Silo,
Merrill, Oregon
7" x 9" | 17.8 x 22.9 cm;
watercolor; 1 hour

trap of believing the sky is always blue and clouds are always white, and sometimes that is exactly what a sketch calls for! Skies don't always need to be really complex. But by taking the time to give it a little more observation, you may find that adding in some quick shadows or giving extra attention to color can give your sketch an added sense of depth.

Observation Checklist

- ❏ Which is darker, the sky or the clouds?
- ❏ What percentage of the sky is covered by clouds? Are they concentrated in one area, or over most of the sky?
- ❏ Is the sun in front of the clouds, or behind them?
- ❏ Do you see shadows on the clouds? If yes, are they on the top, bottom, or in the middle?
- ❏ What color are the shadows? What colors are the clouds where they are being hit by light?
- ❏ What color is the sky above your head? What color is it closer to the horizon?
- ❏ What are the cloud shapes you see? Thin and wispy? Big and fluffy?
- ❏ Look at the clouds' edges; are they hard or soft?
- ❏ Do you see any light coming through the cloud?

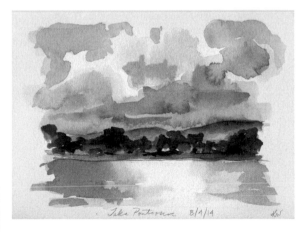

C KATIE WOODWARD
Lake Pontoosuc,
Pittsfield, Massachusetts

*5" x 7" | 12.7 x 17.8 cm;
watercolor, graphite pencil;
20 minutes*

Gallery: Clouds

⊃ VIRGINIA HEIN
Mojave Desert Clouds,
Twentynine Palms, California

10" x 14" | 25.4 x 35.6 cm;
pencil, watercolor, and gouache
on gray toned paper; 1 ½ hours

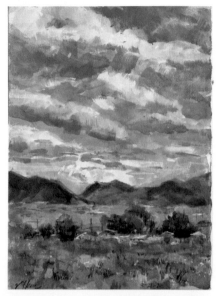

☉ BHUPINDER SINGH
Pense Clouds, Saskatchewan, Canada

6½" x 10" | 16.5 x 25.4 cm;
acrylics on cellulose paper; 45 minutes

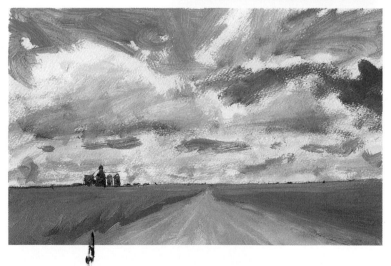

If you're working in watercolor, you may consider making a plan for your clouds. Often, this is going to be preserving the white of the paper, whether that means not putting water on those areas at all, or putting in your sky color and using a dry brush or sponge to pull the wet paint back up. Depending on the color of the clouds, you may drop other colors onto them when the sky itself is dry. Experiment with techniques and see how the edges of the clouds differ. Different effects may be better for different skies. Likewise with graphite or vine charcoal, you can preserve the paper or erase your whites back out.

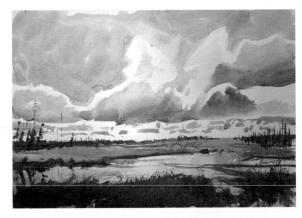

☾ BHUPINDER SINGH
White Bear Lake, Saskatchewan, Canada
11" x 16" | 27.9 x 40.6 cm; watercolor on rag paper; 30 minutes

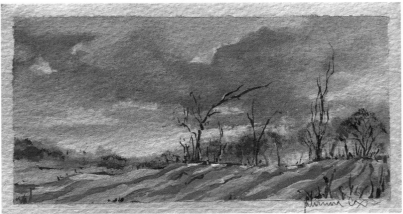

☾ JULIANNA COX
January, Belwood, Ontario, Canada
2" x 3½" | 5 x 8.6 cm; Acryla Gouache

SUNRISES AND SUNSETS

When the sun rises and falls, blue skies can be replaced with a riot of color, as lighting situations change quickly and dramatically. Whether the sky is more muted or more colorful, it will likely appear warmer than usual. Compare the color of the sky at the horizon in the direction of the sun to the color of the sky directly above, and to the color along the horizon behind you. It will likely be a gradient in both value and color that can change depending on the weather. If the sun is below the horizon line, the horizon will likely appear warmer and lighter than the rest of the sky. Even during the day with a blue sky, the color and value varies if you are seeing the sky overhead versus the sky visible closer to the horizon. The most important part of sketching a sunrise or sunset? Work fast. The light is going to change on you minute by minute, so making quick choices and sticking to them is key.

⟳ KATIE WOODWARD
The New Ideal, Birmingham, Alabama
6" x 6" | 15.2 x 15.2 cm; watercolor, graphite pencil,
white Uni-ball Signo gel pen; 45 minutes

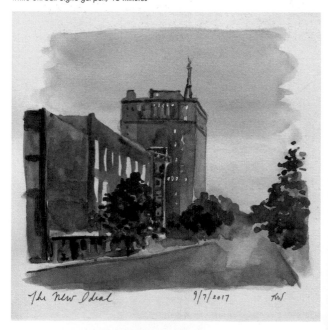

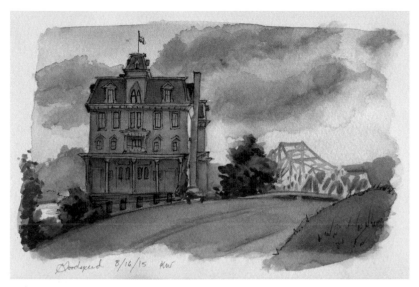

⋒ KATIE WOODWARD
Goodspeed, East Haddam, Connecticut
6" x 8" | 15.2 x 20.3 cm; watercolor, graphite pencil

⋒ MAX WHITE
Dusk over Godstone, United Kingdom
3" x 6" | 7.6 x 15.2 cm; oil on card; 20 minutes

Sunsets and sunrises have a lot in common. A similar color scheme and similar lighting conditions. In both, the sun is casting long shadows of anything in its path. Light tends to be more colorful, ranging from lavender to pink or orange, versus the white light of midday, which can affect the look of your subject and the colors filling the shadows it casts. You are more likely to see the sun in your field of vision when it is lower in the sky. You may see a halo or "corona" around the sun. Should your sketch include the sun itself; do you see a corona around it? Consider if you see the edge of the sun and if it appears as a defined circle, or if it is obscured by blinding light and you see a soft glow of light radiating out instead. Lightening or using warmer colors in the area around the sun helps give the impression of that glow. Coronas can appear around any light source, whether it is the sun, moon, or a lamp.

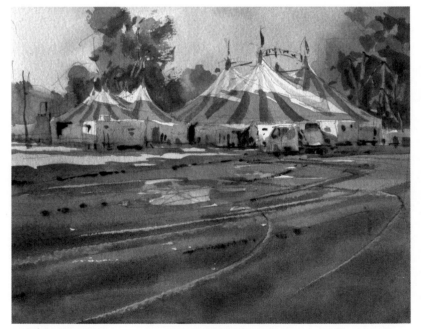

⌒ MIKE KOWALSKI
Silver Circus Sunrise,
Melbourne, Australia

7" x 9" | 17.8 x 22.9 cm; watercolors;
45 minutes

Long shadows cast at sunrise and sunset may extend up and onto vertical surfaces opposite the object casting the shadow, as seen on these circus tents. The tops of the tents are catching the early sun, and as it rises the shadow will fall down the side of the tent until the whole thing is bathed in light.

☾ MAX WHITE
Sunset Over Brighton,
United Kingdom

8" x 8" | 20.3 x 20.3 cm;
oil on canvas; 3 hours
(split into three 1-hour sessions
in the same location)

The corona may extend
over land or objects; by
adding orange to the land
underneath the sun, it helps
intensify the look of the
corona.

☾ MAX WHITE
Moonlight Over Surrey,
United Kingdom

4" x 5" | 10.2 x 12.7 cm;
oil on card; 20 minutes

BACK LIGHT

Especially in the early morning or late in the afternoon, when the sun is low in the sky, we can sometimes see objects being backlit by the sun. This creates a dramatic lighting scheme, which can call for a dramatic sketch! Sometimes you may see edge lighting—when the light hitting the opposite side of the object is so bright, the edge of the object glows, while the rest of what you see is in shadow. Often you will see long cast shadows on the ground, as well.

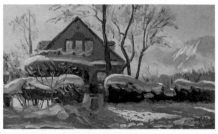

↻ REMINGTON ROBINSON
Snow-Covered House on Mapleton,
Boulder, Colorado
1⅞" x 2⅛" | 4.64" x 7.94"; oil on wood panel

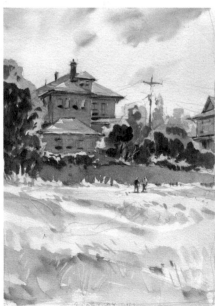

↺ MIKE KOWALSKI
The Boys of Broadway Hill,
Seattle, Washington
7" x 10" | 17.8 x 25.4 cm;
watercolor; 45 minutes

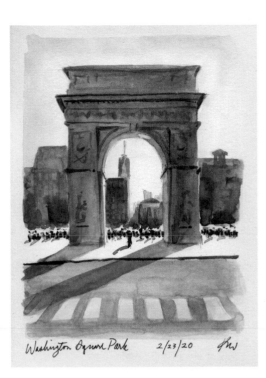

Washington Square Park 2/23/20 KW

◐ KATIE WOODWARD

Washington Square Park,
New York City

*5" x 7" | 12.7 x 17.8 cm; watercolor,
graphite pencil*

☉ KATIE WOODWARD

Bryant Park Fountain,
New York City

*6" x 8" | 15.2 x 20.3 cm; watercolor,
graphite pencil, white Uni-ball Signo
gel pen*

Water that's backlit can sparkle
and glow. Here you can also
see reflected light hitting the
bottom of the upper basin.

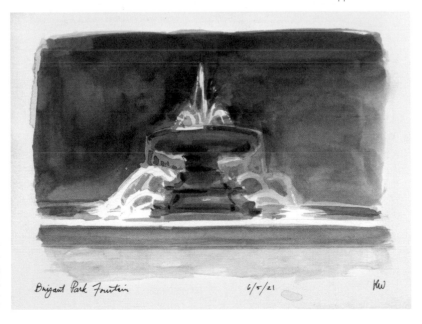

Bryant Park Fountain 6/5/21 KW

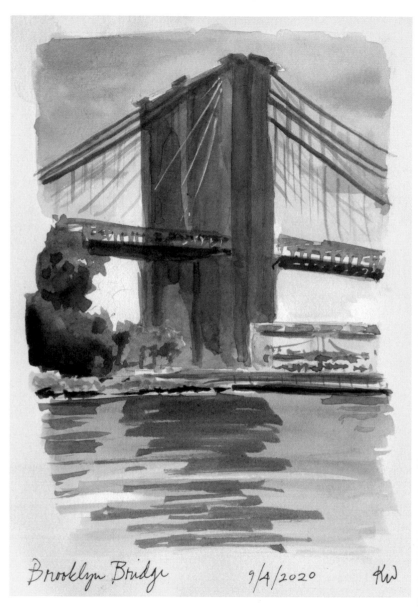

Brooklyn Bridge 9/4/2020 KW

♙ **KATIE WOODWARD**
Brooklyn Bridge, New York City

*5" x 7" | 12.7 x 17.8 cm; watercolor, graphite pencil,
white Uni-ball Signo gel pen; 35 minutes*

KEY IV
REFLECTIONS

After we figure out where the light is coming from, what it is hitting, and where the shadows are, we have to look at how it bounces off the surfaces it hits. These are "reflections." They can happen on even a mildly shiny surface. We may find them on the glass of a window, ever moving waves of the sea, a bronze statue in a park, or the side of a car. Rendering reflections can give the audience information on the surface of an object and add pizazz to a sketch.

An object's reflections depend on the quality of its surface. How shiny is it? Something like a mirror—as shiny as can be—will give you nice, sharp, clear reflections. Transparent glass can give you similarly sharp reflections, but they're often interspersed with anything you're seeing through the glass itself. This can soften the reflections and means you often don't get a perfect, unbroken reflection. Matte surfaces don't have any reflections, although sometimes you can still get reflected light bouncing off the object and filling the shadow. This happens most often with lighter objects, or ones that are a really bright color.

By thinking about how light hits an object while sketching, we're better able to replicate it and give the viewer more tactile information.

REFLECTIONS IN WATER

Some light breaks the surface of the water, and some is scattered off the surface. How much of that reflected light comes to us can depend on a number of things, especially how much the water is moving. Take a minute to examine the surface, using the provided checklist as a guide. Frequently, water is in motion and we don't get a clear reflection, but we can see bits and pieces through the ripples. A few quick strokes can give the illusion of a reflection with very little effort!

➲ YONG HONG ZHONG
Pond Reflection,
Lake Oswego, Oregon

9" x 12" | 22.9 x 30.5 cm; watercolor;
1 ½ hours

Look at how light the water is where it is reflecting the sky. This is juxtaposed with a darker reflection, perhaps of nearby trees? Note how the dark section is warmer and darker closer to the artist, and cooler and lighter farther away. That change gives a wonderful sense of depth. This is also a great example of being able to see something under the water, while still seeing reflections above. Note how we can only see the stones underneath the water when they are closer, and how we can see through the water better where it is in shadow rather than where we see the reflection of the sky.

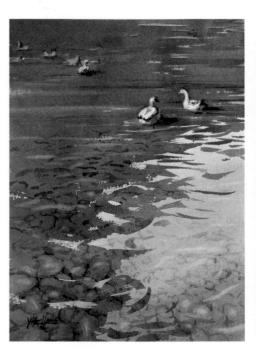

Observation Checklist

- ❏ How clear is the water?
- ❏ Am I seeing anything under the surface?
- ❏ Is the top still, or is it moving?
- ❏ If there are ripples or waves, how big are they?
- ❏ What direction is the water moving? If there are ripples, what pattern are they making?
- ❏ Are there shadows cast on the water's surface?
- ❏ Do you see anything reflected in the surface?
- ❏ Is that reflection broken up, or more like a mirror reflection?

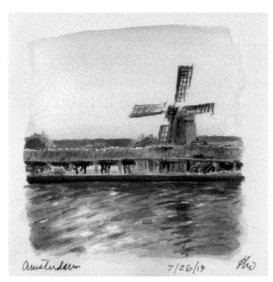

Amsterdam 7/26/17 kw

↻ KATIE WOODWARD
Amsterdam Windmill,
Amsterdam, Netherlands

*4" x 4" | 10.2 x 10.2 cm; watercolor,
graphite pencil, white gel pen*

If bright sunlight is reflecting off
the tops of the ripples in the
water, adding in short dashes
of white can help add a little
sparkle! The brightest sunlight
bouncing off the water here was
done with white gel pen. The
lightest area is the reflection of the
sun itself since it was positioned
in front of me as I sketched. Some
darker brushstrokes show where
the windmill is reflected. Because
there were so many ripples on
the surface of the water, you
don't get a perfect mirror
reflection of the windmill, only a
suggestion of size and shape.

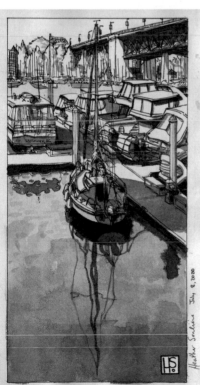

↻ HEATHER SOULIERE
Boats on False Creek, Vancouver, Canada

*3¼" x 6½" | 8.2 x 16.6 cm; HB pencil, eraser,
Speedball Super Black India Ink mixed with water,
Sakura Micron pen size 01; 45 minutes*

Here you can see Heather captured a really
clear reflection, with just enough wobble in
the lines to show the viewer that the water
isn't perfectly still! Note how this reflection
differs from the one in the windmill sketch,
and how that affects our perception of the
movement in the water.

Gallery: Reflections

↻ ALEX HILLKURTZ
Amsterdam Sunshine,
Amsterdam, Netherlands

*8" x 8" | 20 x 20 cm; ink and
watercolor; 30 minutes*

↻ SHARI BLAUKOPF
Yellow Wall,
Montreal, Canada

*12" x 9" | 30.5 x 22.9 cm;
gouache; 1 ½ hours*

You may have an ocean,
or just a shallow puddle.
A reflection can be
present no matter the
depth of the water.

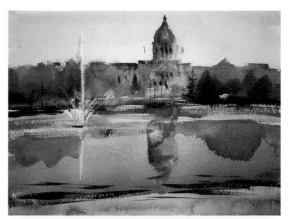

☾ BHUPINDER SINGH
Fall Around Wascana, Saskatchewan, Canada

12" x 16" | 30.5 x 40.64 cm; watercolors and pencil; 1½ hours

☾ MIKE KOWALSKI
Norwegian Wood, Port Townsend, Washington

9" x 12" | 22.9 x 30.5 cm; watercolor; 1 hour

☽ KATIE WOODWARD
Temple of Dendur, Metropolitan Museum of Art, New York City

3" x 6" | 7.6 x 15.2 cm; watercolor, graphite pencil, Pigma Micron pen

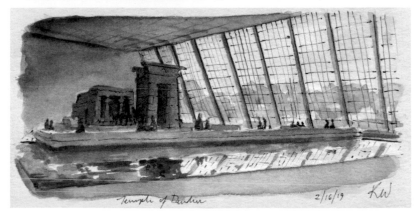

Temple of Dendur 2/16/19 KW

FLOOR AND CEILING REFLECTIONS

Reflections don't always appear in the most expected places. We expect to see them in mirrors, windows, and water, but they can also appear on floors, or glossy tiled ceilings. Maybe it has recently rained and there is a thin layer of water on the asphalt, or maybe you are looking at a recently buffed museum floor. This type of reflection can be fun both to replicate and to imagine and include in a sketch, even if you don't see it in front of you. The reflection may be dull and undefined, or it may be an exact copy, depending on the surface you are seeing (or, what makes sense for your sketch.). When in doubt, look at the edges of the reflection to guide you.

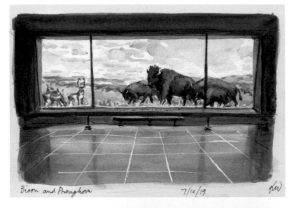

➲ **KATIE WOODWARD**
*Bison and Pronghorn,
American Museum of
Natural History,
New York City*

*5" x 7" | 12.7 x 17.8 cm;
watercolor, graphite pencil,
white Uni-Ball Signo gel pen,
Pigma Micron pen; 1 ½ hours*

This shiny museum floor gave me a good excuse to add a reflection to my sketch. The sections of floor were divided by very reflective brass strips, so I used my white gel pen to add those in at the end (note the black pen used for the same strips outside the reflected area).

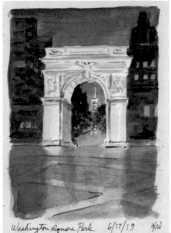

➲ **KATIE WOODWARD**
Washington Square Park, New York City
*5" x 7" | 12.7 x 17.8 cm; watercolor, graphite pencil,
white Signo gel pen; 1 hour*

🔊 When seeing an object floating in water at a distance or when your eye is closer to the water level, the reflection may be a perfect mirrored image. If looking at an object at a steeper angle, from overhead, you will likely see the underside of the object, and a shorter reflection. Reflections can appear longer and stretched when on a less smooth surface, like moving water with ripples.

Reflections hinge on where an object meets the water. Far away objects that don't touch your reflective surface hinge on where they *would* hit the surface if it continued and intersected with them. Sound complicated? Don't worry, you don't need to do math. When in doubt come back to observation. I have utilized the "fake it 'til you make it" approach to reflections, as they are something that can often have undefined edges and aren't the full focus of a sketch, making it the perfect thing to fake.

Gallery: Floor and Ceiling Reflections

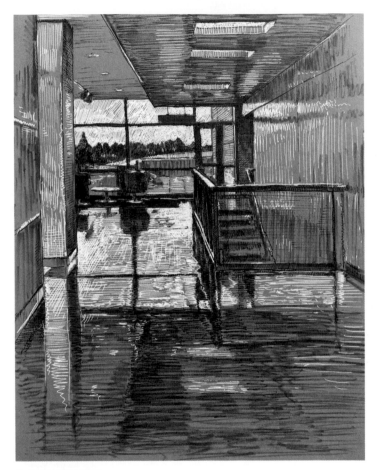

ᗡ DOUG RUSSELL
Visual Arts Building Hallway, University of Wyoming, Laramie, Wyoming

14½" x 11½" | 36.8 x 29.2 cm; Platinum Carbon Black ink in a fountain pen, white Signo gel pen, Iroschizuku Kiri-same gray ink in a water brush on brown Stonehenge paper; 3 hours

Tip

Reflections in a surface parallel to the ground (like a floor, ceiling, or body of water) are often going to be a vertical mirrored imprint of the objects they are reflecting. With a reflection of a rectangular object on a ceiling or floor, the vertical lines of the rectangle will continue straight up or down into the reflection.

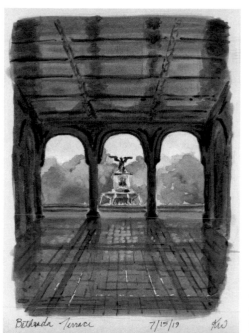

Bethesda Terrace 7/15/19 KW

☾ KATIE WOODWARD
Bethesda Terrace,
Central Park, New York City

5" x 7" | 12.7 x 17.8 cm; watercolor,
graphite pencil, Pigma Micron pens,
white Uni-ball Signo gel pen; 1 ½ hours

☽ KATIE WOODWARD
Union Station, Washington, D.C.

6" x 8" | 15.2 x 20.3 cm; watercolor,
graphite pencil, Pigma Micron pens,
white Uni-ball Signo gel pen; 45 minutes

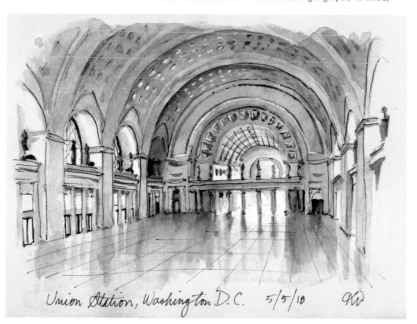

Union Station, Washington D.C. 5/5/18 KW

WINDOWS AND GLASS

Cityscapes are often full of reflections; window glass provides a great opportunity to explore reflective surfaces. Some skyscrapers may be entirely covered in shiny surfaces, or you may just have small windows reflecting light. Let's start with observation.

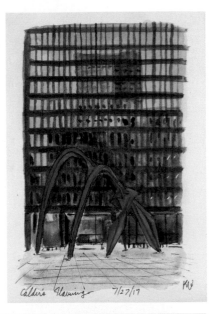

⊃ **KATIE WOODWARD**
Calder's Flamingo, Chicago, Illinois
4" x 6" | 10.2 x 15.2 cm; watercolor, graphite pencil,
Pigma Micron pen; 30 minutes

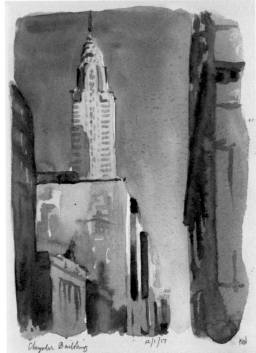

⊃ **KATIE WOODWARD**
Chrysler Building, New York City
5" x 7" | 12.7 x 17.8 cm; watercolor,
graphite pencil

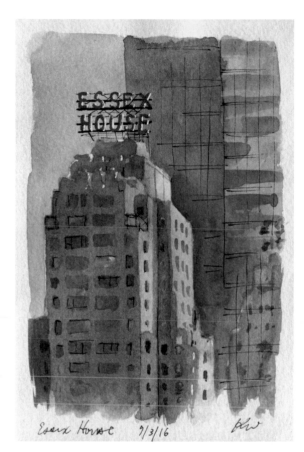

☾ KATIE WOODWARD
Essex House,
New York City

*4" x 6" | 10.2 x 15.2 cm;
watercolor, graphite pencil,
Pigma Micron pen, white Uni-
ball Signo gel pen*

Here, light was hitting the opposite side of Essex House, while the building beyond it reflected that brightly lit side back at me.

Observation Checklist

❏ What color is the window?
❏ Is the window lighter or darker in value than the wall it sits in?
❏ Are the reflections in the windows uniform, or varied?
❏ Do I see shapes of anything reflected clearly in the surface?
 Can I figure out what is being reflected?
❏ Can I see anything through the glass, on the inside of the window?

Even when you aren't doing a closer study of a window, you can use reflections of far-off windows in your sketches. Some may reflect sky or nearby objects and appear as different colors from a distance. When dotting in windows, changing color or value can help add a nice detail and texture to a sketch. I sometimes call this *visual noise*—something that just adds a little detail and interest to a sketch but doesn't necessarily require a lot of work. You never have to match window for window what you see, but just taking a second to observe can inform that choice. On a part of a building in shadow, a window may still be reflecting sky and be seen as a pop of light on an otherwise dark wall. The same idea can be used in night sketches to show windows that are on or off (or, are lit with different types of light). In lieu of reflections, windows may look different whether they are open or closed or have different colored curtains! Little things like this can help give life to a sketch, and give a better sense of lighting, with very little effort.

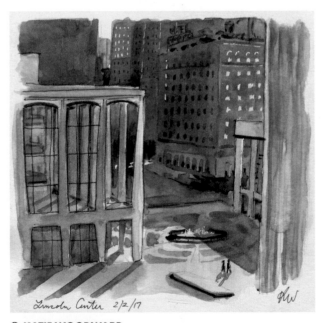

Lincoln Center 2/2/17

⋂ KATIE WOODWARD
Lincoln Center, New York City

*6" x 6" | 15.2 x 15.2 cm; watercolor, graphite pencil,
white Uni-ball Signo gel pen, Pigma Micron pen*

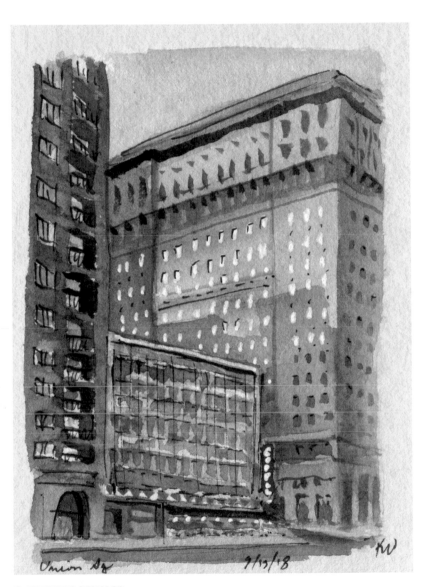

Union Sq 9/13/18 KW

⋒ KATIE WOODWARD
Union Square, New York City

3" x 4" | 7.6 x 10.2 cm; watercolor, graphite pencil,
white Uni-ball Signo gel pen, Pigma Micron pen; 1 hour

When observing windows up close, we sometimes see full reflections and other times we just see through to the interior. Often, it's a mix of both. I usually take a minute to piece together what I'm seeing: Is it reflection, or is it interior? If I'm seeing a reflection, I start by trying to figure out what is being reflected.

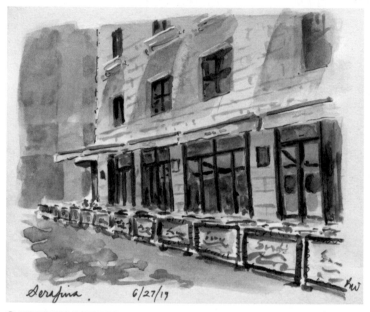

○ **KATIE WOODWARD**
Serafina, New York City

5" x 6" | 12.7 x 15.2 cm; watercolor, graphite pencil, white Signo gel pen, Pigma Micron pen; 1 ½ hours

⊃ **KATIE WOODWARD**
Watch and Jewelry Repair, Brooklyn, New York

3" x 4" | 7.6 x 10.2 cm; watercolor, graphite pencil, white Uni-ball Signo gel pen; 30 minutes

How bright the reflection is affects how much you can see through the window. Since the reflections on this window were very soft, you could mostly see what was inside through the window.

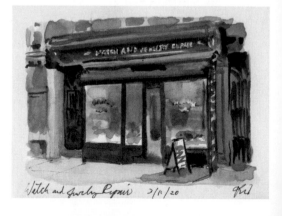

☊ ALEX SNELLGROVE
Hair and Beauty Salon, Enmore Road, Sydney, Australia
8¼" x 11¾" | 21 x 29.8 cm (A4); markers (Posca, Tombow, Fineliner)
and watercolor pencil on a prepared acrylic background
(not made specifically for this purpose); 1½ hours

"This landmark shop is now a Turkish restaurant but all the original features are intact. Most Sydneysiders have a soft spot for the garish pink and purple enamelled shop facade on busy Enmore Road, and I found it irresistible. The background was brown, lime green, yellow ochre, and other dull colors. You can see traces of it in the top right corner and in the window reflections. The other side of the street was sunny, but I was in the shade."
—Alex Snellgrove

REFLECTIVE OBJECTS

Reflections on sculpture and other three-dimensional objects can be especially fun to render! Reflections can tell the viewer about the shape of an object. Musical instruments are a great example of this. Depending on the level of shine of the object, this may be anything from a soft highlight to indicate a subtle shine, to a full, detailed colorful reflection of the object's surroundings. Reflections, like shadows, can help give an object in a sketch volume to visually sculpt a scene.

◯ MIKE KOWALSKI
Vic and His Tuba,
Port Angeles, Washington

7" x 10" | 17.8 x 25.4 cm; watercolors; 30 minutes

Note the skin color used in the reflection facing the musician. The sharp reflections we see on the tuba, coupled with the use of colors that appear on the musician, tell us that the instrument has a very shiny, mirrored surface.

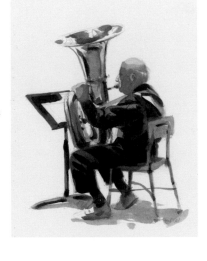

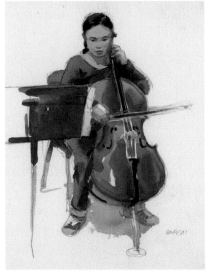

◯ MIKE KOWALSKI
The Cellist, Seattle, Washington

7" x 10" | 17.8 x 25.4 cm; watercolors; 30 minutes

Here, the reflections are much more subtle than on the mirrored brass of the tuba, but you can still tell that the cello has a very shiny coating. For objects that are shiny, but not mirrored, you will most likely see the nearby points of highest contrast reflected, like highlights from nearby light sources.

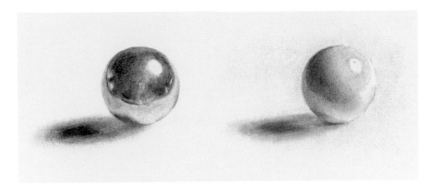

Note that on this shiny white cue ball, you still see the light source reflected, and the high contrast area of the edge of the white table, but most of the details seen on the mirrored ball are obscured.

◯ DOUG RUSSELL
Labor Day Back Yard,
Laramie, Wyoming

10" x 16" | 25.4 x 40.6 cm; Platinum Carbon Black ink, Prismacolor pencil in a beige Stillman & Birn Nova sketchbook; 2 hours

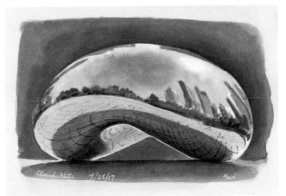

◯ KATIE WOODWARD
Cloud Gate,
Chicago, Illinois

5" x 7" | 12.7 x 17.8 cm; watercolor, graphite pencil, Pigma Micron pens, white Uni-ball Signo gel pen

Here you can see how the shape of the sculpture bends the shapes of the reflections. The buildings are compressed together, and the grid of the pavement conforms to the shape of the bean.

TRANSPARENT OBJECTS

Flat windows, while made of glass, sometimes miss out on a fun aspect of shaped glass or water: refraction. Light bends as it travels through a glass shape (or liquid) and can come out in unexpected ways; we still see shadows, but we can also get more focused light. Often, translucent objects are also reflective, which means you have to consider how reflective they are in addition to what you are seeing through them.

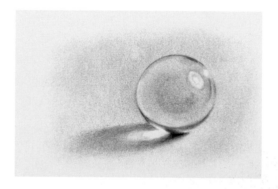

⊃ SUE YEON CHOI
Waiting for Morning Coffee,
San Francisco, California

9¼" x 10¾" | 23.4 x 27.4 cm;
pencil, Copic Sketch Markers in
Neutral Gray N0, N2, N4, N6;
1 hour

As light filters through glass, you will still see a shadow, but it won't be solid as you would see with an opaque object. Areas where the glass is thicker will be darker, while other areas may leave no shadow at all. Light filtering through the glass gets refracted and may come out in unexpected places.

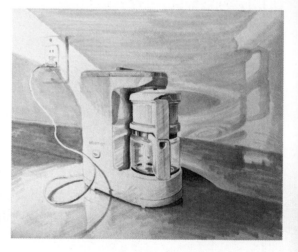

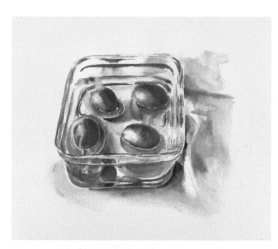

☾ ANITA ALVARES BHATIA
Floating Tomatoes,
Mumbai, India

*7" x 6" | 18 x 15.5 cm; pencil
and watercolors; 1 ½ hours*

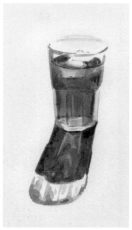

☊ KATIE WOODWARD
Sweet Tea, New York City

*7" x 9" | 17.8 x 22.9 cm; graphite
pencil, watercolor*

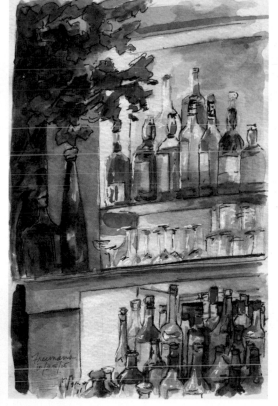

☾ KATIE WOODWARD
Freemans, New York City

*5" x 8" | 12.7 x 20.3 cm; graphite
pencil, watercolor, Pigma Micron
pens, white Uni-ball Signo gel pen*

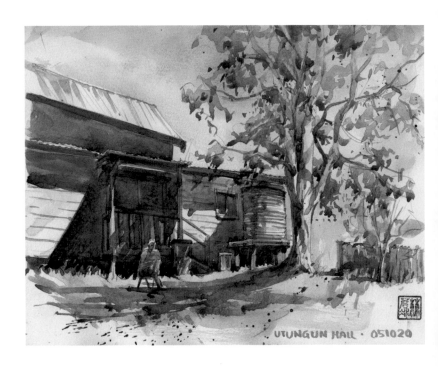

UTUNGUN HALL · 051020

Prospect Park 6/28/19 JW

KEY V
FOLIAGE

Foliage can feel intimidating to sketch, in part because the lighting schemes are so complex! Having to figure out what is being hit by light, what is in shadow, and what light is filtering through translucent leaves can be overwhelming. As with anything else, it takes practice, but it gets easier if we better understand what we are looking at and simplify as necessary. Let's demystify the process a bit.

☾ ROOI PING LIM
Relaxing After a Long Day,
Utungun Hall,
Untungun, NSW, Australia

8" x 10¼" | 20 x 26 cm;
pencil and watercolor; 1 hour

WARM GREENS VERSUS COOL GREENS

One of the hardest things about painting foliage is that it is translucent, which lends itself to a wide range of greens, even on the same plant. You can have light hitting the front of one leaf, next to another where you are seeing the light filter through from behind. It is sometimes easiest to group together pieces of foliage where possible, finding a color that can suit a whole area that averages together the large variety of colors and values that can be visible in foliage. Use the marks made on the edge of your shape, and perhaps some marks made within, to help define it as foliage, rather than worrying about each individual leaf.

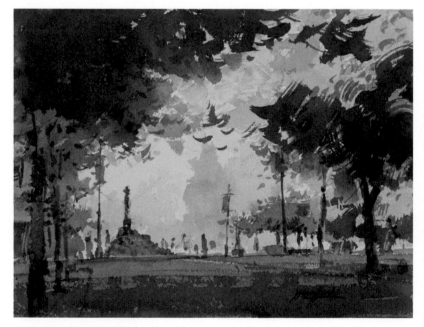

∩ YONG HONG ZHONG
Plein Air Painting at Downtown Lake Oswego,
Lake Oswego, Oregon

8" x 10" | 20.3 x 25.4 cm; watercolor; 1 hour

Letting bits of light sky peek through the foliage helps show the texture of leaves without having to sketch every individual leaf with its own highlights and shadows.

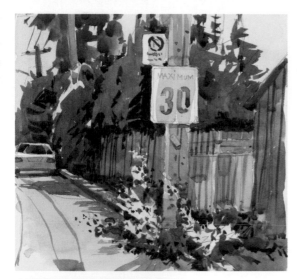

☾ SHARI BLAUKOPF
School District,
Montreal, Canada
8" x 8" | 20.3 x 20.3 cm;
watercolor, pencil; 1 hour

Observation Checklist

- ❏ Are the majority of the leaves in shadow, frontlit, or backlit?
- ❏ Are backlit leaves warmer or cooler than frontlit leaves? Leaves in shade?
- ❏ What are the dappled shadow shapes of the cast shadow? Do you see any trunk or branch shadows?
- ❏ Can you combine a piece of foliage into groups? Maybe by tree, or by groupings of trees?

◯ JULIANNA COX
River Afternoon, Elora, Ontario, Canada
6" x 8" | 15.2 x 20.3 cm; watercolor

Leaves being hit with light can glow warm, especially when lit from behind! This can also happen with flowers and other translucent objects.

Tip

Focus on a smaller area rather than a full scene to do a more detailed study of how light affects leaves.

SHADOWS UNDER FOLIAGE

With foliage, it's easy to get caught up in all the leaves, but don't forget about what supports those leaves! Showing where the trunk and branches of a tree show through can give the viewer useful information, making these details more important to a composition than the actual foliage. It can transform indistinct green shapes into a tree, with just a few strokes. How dense are the trees? In the treetops, foliage may all blend together, but closer to the ground you'll be able to see the tree's trunk between them. At the trunk height you may see light coming through from beyond, or you may have a forest where you are seeing mostly shadow.

> **Tip**
> Decide early on if your trunks are going to be light or dark against whatever is behind them.

↪ KATIE WOODWARD
Gramercy Park,
New York City

3" x 4" | 7.6 x 10.2 cm;
watercolor graphite pencil,
Pigma Micron pens

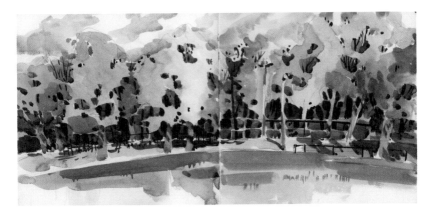

∩ SHARI BLAUKOPF
Windy Park, Montreal, Canada

16" x 8" | 40.6 x 20.3 cm; watercolor; 1 hour

When at the edge of a wooded area, the space beyond the tree trunks may be in shadow, causing the trunks to appear light against the darkness.

∪ KATIE WOODWARD
Central Park Conservatory Waters, New York City

4" x 4" | 10.2 x 10.2 cm; watercolor, graphite pencil, Pigma Micron pen, white Uni-ball Signo gel pen

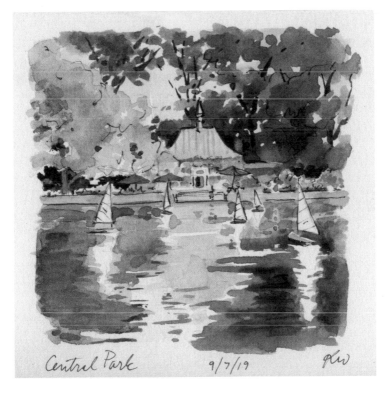

Central Park 9/7/19 klw

SUNBEAMS

As light pours through foliage, you may see sunbeams. They can be especially prominent when there is a lot of dust, moisture, or smoke in the air for light to catch. The sun hits these particles and you can see the path of the sun as it passes through leaves or clouds as a three-dimensional object. Or, conversely, with similar conditions you can have a shadow beam if instead of having mostly shadow and a little sun, you have mostly sun with only a little blocked out (like sun on a building casting a huge shadow, or sun on a single tree or gravestone.).

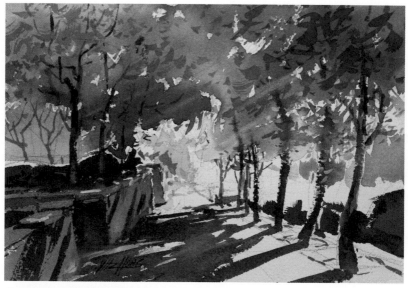

⋂ **YONG HONG ZHONG**
Plein Air Painting at Downtown Lake Oswego,
Lake Oswego, Oregon

7" x 10" | 17.8 x 25.4 cm; watercolor; 1 hour

Prospect Park 11/7/2020 KW

◑ KATIE WOODWARD
Sunbeams in Autumn,
Prospect Park,
Brooklyn, New York
5" x 7" | 12.7 x 17.8 cm; watercolor,
graphite pencil, white gel pen

No Foliage? No Problem!

Sunbeams can show up
any time bright sunlight is
pouring out from behind an
object. You can often see
them coming out from behind
clouds, or even coming in
through a window.

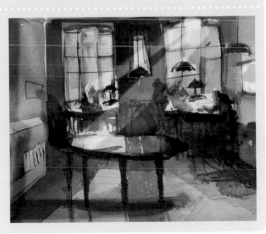

➲ TINE KLEIN
The Reading Room,
Basel, Switzerland
8" x 11" | 20 x 28 cm; watercolor;
in two sessions: 15 minutes and
35 minutes

DAPPLED LIGHT

Aside from the foliage itself, we have to figure out how the light filters through the leaves. This can create tangled shadow patterns of dappled light on the ground, but just because they look complicated doesn't mean sketching them has to be!

Try looking at these shadows as a single, broken shape. Like a slice of swiss cheese, the shadow shape will have holes in it. Instead of having to paint the shadow of each individual leaf, play with the outline of the shadow, leaving unpainted areas within it to give the idea of dappled light. If you are working in an opaque medium, you can add dots of light back in over your shadow, or if you are using graphite, you can erase out areas.

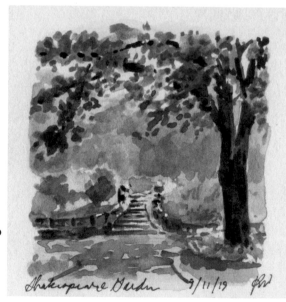

⊃ **KATIE WOODWARD**
Shakespeare Garden,
New York City

3" x 3" | 7.6 x 7.6 cm;
watercolor, graphite pencil,
white Uni-ball Signo gel pen

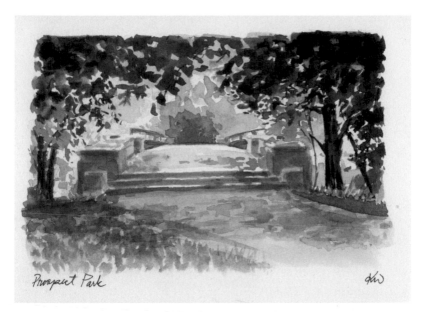

Prospect Park

⋂ KATIE WOODWARD
Prospect Park,
Brooklyn, New York

5" x 7" | 12.7 x 17.8 cm;
watercolor and graphite pencil

Another approach: adding the shadows in layers. By dotting in the shadows and placing shadow shape atop shadow shape, it gives the impression the leaves are more translucent and the light hitting the ground is filtered through the leaves themselves, rather than just around them. For this sketch I added one larger shadow shape then proceeded to add layers of dashed shadows on top, as the dappled light I was seeing was very broken up, sometimes the light on the ground was pure sun, other times it was filtered through translucent leaves.

Tip

Remember as you work that the shadows are foreshortened; if you look at them from directly above the edges will be fuller and rounder. Viewing at an angle means that leaf-shaped shadows may appear as thin lines rather than fuller circles or more recognizable leaf shapes.

Gallery: Dappled Light

⊃ HEATHER SOULIERE
Fountain on Bute Street,
Vancouver, Canada

4" x 6½" | 10.1 x 16.6 cm; HB pencil,
Speedball Super Black India Ink mixed
with water, Sakura Micron pen Size
01, watercolor paint brush, Moleskine
Sketchbook; 1½ hours

☾ HEATHER SOULIERE
Morning Light,
Vancouver, Canada

4" x 6½" | 10.1 x 16.6 cm; HB pencil,
Speedball Super Black India Ink mixed
with water, Sakura Micron pen size 01,
watercolor paintbrush, Moleskine
sketchbook; 1 hour

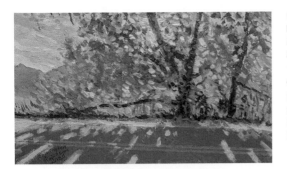

↻ REMINGTON ROBINSON
Roadside Cottonwood Tree in Autumn, Colorado
1⅞" x 2⅛" | 4.64 x 7.94 cm; oil on wood panel

See the variety in the foliage: the brighter yellow backlit leaves, and the more ochre leaves in shadow.

↻ ALEX SNELLGROVE
The Garden Gate, Blackheath, Blackheath, Australia
8¼" x 11¾" | 21 x 29.8 cm (A4); markers (Posca, Tombow, Fineliner) and watercolor pencils on a prepared acrylic background of mostly blue and purple (not made specifically for this); 1½ hours

"Late afternoon sunlight filters through the leaves of the crabapple tree and casts dappled shadows on the slats of the open gate. The road outside is bright with sunlight, which also catches the tips of the agapanthus flowers next to the path."
—Alex Snellgrove

Observation Checklist

- ❏ What is the shape of the dappled shadows you see on the ground?
- ❏ Within the dappled shadow, is there more shadow or light?
- ❏ Do you see any shadows of branches or trunks cutting across?
- ❏ Is the dappled shadow only on the ground, or is it also on nearby building walls, tree trunks, or other objects?
- ❏ Are the shadows wrapping around surfaces they cross and conforming to those shapes?
- ❏ Are the edges of the shadow hard or soft?

GALLERY: FOLIAGE

> **Tip**
>
> Incorporate yellows, blues, and oranges into your foliage, and not just a mix of greens.

⊃ **DAVID LOWTHER**
Sett Valley Trail, Derbyshire,
United Kingdom

8" x 11" | 20.3 x 27.9 cm;
pastel and Viarco ArtGraf;
30 minutes

Add mood by blocking in light with dark shadows.

> **Tip**
>
> Consider how you make different kinds of marks and what might be best to portray foliage. Do you want to use tiny scribbles, fat dashes, long fluid lines, or juicy fields of color? Are the shapes round, or pointed? Do you want to spatter paint across the page for added texture? Experiment with different marks before deciding the texture you want to use.

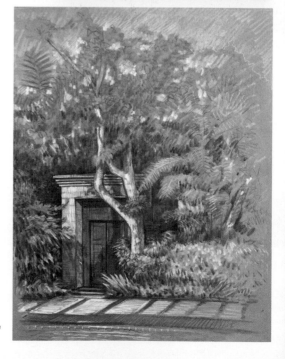

⊃ **DOUG RUSSELL**
Sanur, Bali, Indonesia

15" x 11" | 38.1 x 27.9 cm;
Prismacolor pencil on brown
Stonehenge paper; 2 hours

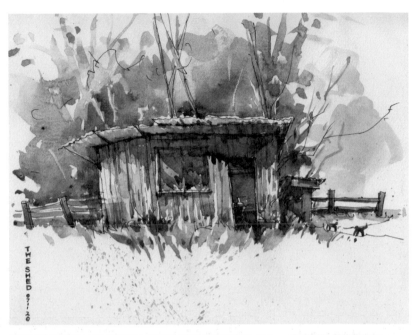

◐ ROOI PING LIM

Leigh's Shed, Wyong Creek, NSW Australia

8" x 10" | 20 x 25 cm; pen and watercolor; 45 minutes

◑ ROOI PING LIM

Path on the Way Home, Wyong Creek, NSW Australia

10" x 8" | 26 x 20 cm; pencil and watercolor; 45 minutes

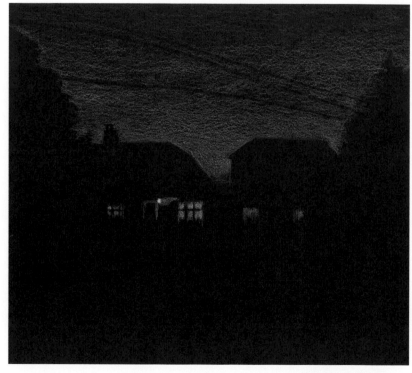

Ω TINA KOYAMA
Predawn on Thanksgiving,
Seattle, Washington

7" x 7" | 17.8 x 17.8 cm;
colored pencils, black paper;
40 minutes

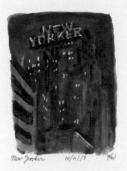

New Yorker 10/u//9 PW

KEY VI
NIGHT SCENES

Night scenes turn lighting on its head as local color becomes nearly irrelevant. We know there are big fluctuations in our perception of local color as the sun moves during the day. At night this is exacerbated by a general lack of light punctuated by very specific light sources. As it gets darker, the cones in our eyes responsible for perceiving color have a harder time doing their job, so you may notice that colors around you appear more neutral as light dims. Colors that appear vibrant and high chroma in full light may slowly fade to gray as the sun sets and they become harder to see. This can make well-lit areas appear even more colorful by comparison, or you may just have amber glowing windows. In addition to color being less straightforward, and we are likely to encounter a number of different light sources, all of which may have differing colors and qualities. The good news is, there are lots of ways to simplify a scene and dial in what we see before us so we can tackle these scenes with abandon!

MULTIPLE LIGHT SOURCES

A common light source for nighttime scenes is the light filtering through windows, as seen from outside. Often the quality of light is warm and soft, from multiple light sources or even the light of one lamp bouncing around the white walls of a room before it makes its way outside. The escaping light may have a slight corona if you want it to feel especially glowy. Light exiting a door or window on the ground level may hit street level objects and you may see the light hitting the ground. Are the edges of that light hard or soft? Perhaps they are more defined closer to the window and fuzzy as the light scatters farther from its source?

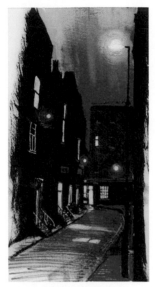

Ω DAVID LOWTHER
Manchester Street by Night,
United Kingdom

6" x 10" | 15.2 x 25.4 cm; marker, pen, and ink; 20 minutes

Tip

Your highest chroma/most saturated colors will likely be closest to the light sources in the scene.

Ʊ YEVHENNI OMETSYNKSYI
Retroville at Sunset,
Kyiv, Ukraine

iPad, Apple Pencil, Procreate app

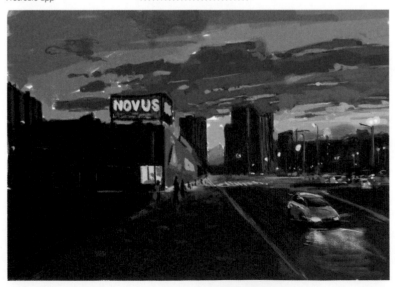

Notice that night scenes often contain multiple light sources. You can have the setting sun, a neon sign, glowing windows, and car headlights all in one view.

Multiple light sources may appear in daytime scenes, too, (below) especially in indoor scenes with light coming in from the windows. We have to consider the color of the light coming in from the windows, treat each window as its own light source, and consider the color of any light sources inside as well. With multiple light sources, we can also have multiple shadows from a single object.

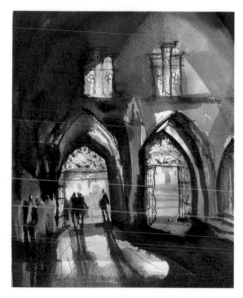

☾ TINE KLEIN
Basel Town Hall,
Basel, Switzerland
21" x 17" | 53.2 x 42.7 cm;
watercolor and fountain pen;
40 minutes

"This is not a church, it is the town hall in Basel, it is a cathedral of democracy. The house's wonderful construction is a red castle from 1500, it is so superb. There is so much to see, murals, statues and stonemasonry that I observed several times before I started to paint. The light inside of the castle wall is fundamentally different to the nearly Mediterranean light outside of the building. The specialty about this is, that it is so dark inside of the inner courtyard, that the powerful colors of the building only start to glow when there is a sun ray kissing the walls." —Tine Klein

NIGHT SKIES

You may notice when painting after sunset that the sky is often not the darkest part of your view. Intuitively we want to drop a black sky into a night scene, but in many situations, this is contrary to what we see in front of us. Especially in big cities, light pollution can keep the sky lighter, while light sources closer to us can cast dark shadows. Pay attention to the color of the sky—maybe it is purple, or navy, or gray! What in your view touches the sky? Check for value; see if the edges of trees or buildings appear darker or lighter than the sky itself. Streetlights may be offering ambient lighting to the ground level of buildings, while the tops remain dark against a lighter sky. The lighting itself can sell a sketch as being a night view: the light pouring out from a store front, a darkened building façade. Simply putting a black sky into a sketch done during the day will likely still not read as nighttime.

Night sketches tend to be darker overall, which can be hard to get used to. It may mean the lightest parts of a sketch get darker than usual to keep the sketch cohesive.

Tip

Put the darkest colors you plan on using on the edge of a loose piece of paper. If you are doing the light colors first (as with watercolor), you can hold that up to compare. Or, drop in your darkest values first (perhaps with waterproof black pen) so you have something to compare as you work. When you are seeing the values compared to white paper as you work, this can trick our eyes and keep the first layers paler than you may want in the end, when most of the paper will be covered with darker values.

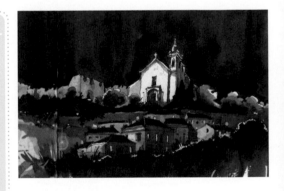

⋂ PEDRO ALVES
Castle and Santa Maria Church, Torres Vedras, Portugal
10" x 6" | 25 x 15 cm; ink and watercolor; 50 minutes

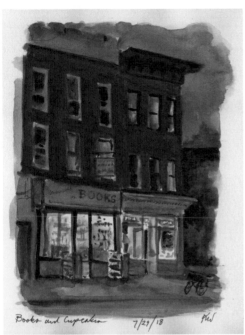

☾ KATIE WOODWARD
*Books and Cupcakes,
Brooklyn, New York*

5" x 7" | 12.7 x 17.8 cm; watercolor,
graphite pencil, white Uni-ball Signo gel
pen, Pigma Micron; 1 hour

Books and Cupcakes 7/29/18 KW

☽ TINA KOYAMA
Predawn Fog

7" x 7" | 17.8 x 17.8 cm; colored pencils,
black paper; 30 minutes

STREETLIGHTS

Oftentimes, our light source is the sun, or a lamp attached to a wall or ceiling. Streetlights are a fun but unusual light source, since we can see how they are affecting objects a full 360 degrees around them. They can cast a wide radius, hitting not only the street and walking paths they are meant to illuminate, but also surrounding trees, people, and buildings.

Tip

Check the color of the foliage in your scene! It usually doesn't look green at night because it is rarely getting enough light. Our brain always wants to make foliage green when we *know* that is the local color, but making other choices can help it look closer to reality and fit better with a scene.

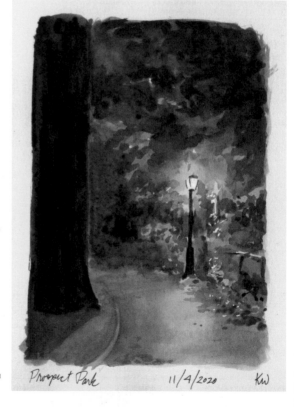

↺ KATIE WOODWARD
Prospect Park,
Brooklyn, New York
5" x 7" | 12.7 x 17.8 cm;
watercolor, graphite pencil and
Pigma Micron pen

Notice how the light hits the nearby foliage, and the shadow cast by the tree. I kept the top of the pole warmer and lighter than the bottom to add to the corona surrounding the lamp.

Prospect Park 11/4/2020 KW

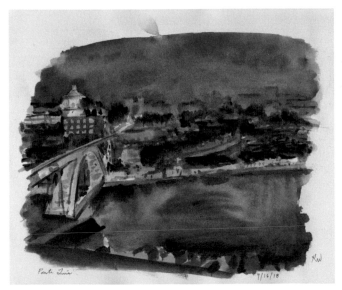

∩ KATIE WOODWARD
Ponte Dom Luís,
Porto, Portugal

8" x 10" | 20.3 x 25.4 cm;
watercolor and graphite pencil

If viewing the lights up close, each streetlight may appear as a glowing orb, but they can affect a far-off sketch as well. While some buildings may have specifically focused architectural lighting, often the primary lighting hitting the faces of buildings at night is ambient lighting from streetlights! Think about looking at a far-off town; do you see the glow of the streets?

Indoor Light Sources

You can get a similar effect with lamps indoors. Here a multi-headed floor lamp casts very directional light, and the upper part of the bookshelf remains dark. When we have lamps (whether streetlights or indoor light sources), the light source is closer to our subject and sometimes will hit the object at an angle rather than from above. This can cause very dramatic cast shadows.

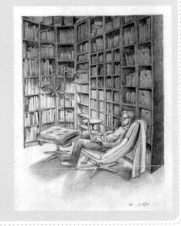

⊃ KATIE WOODWARD
The Favorite Chair, Hartford, Connecticut
8" x 10" | 20.3 x 25.4 cm; graphite pencil

Gallery: Streetlights

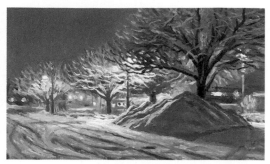

◯ REMINGTON ROBINSON
Snowy Parking Lot Nocturne,
Boulder, Colorado

1⅞" x 2⅛" | 4.64 x 7.94 cm; oil on wood panel

◡ PEDRO ALVES
Ramp Ponte de Lima,
Ponte de Lima, Portugal

12" x 8" | 30 x 20 cm; watercolor,
ink, white acrylic; 80 minutes

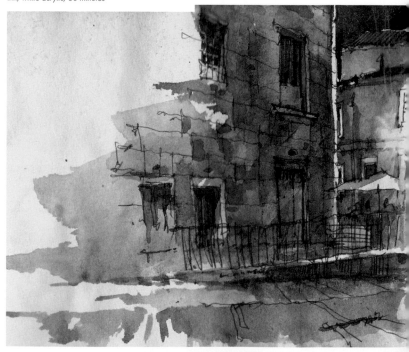

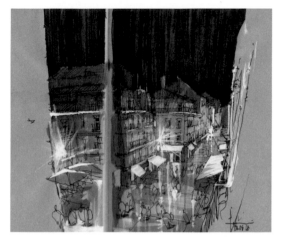

◍ PEDRO ALVES
Portas de Santo Antão Street,
Lisbon, Portugal

7½" x 8⅓" | 19 x 21 cm; toned
paper, watercolor, ink, markers,
white acrylic; 35 minutes

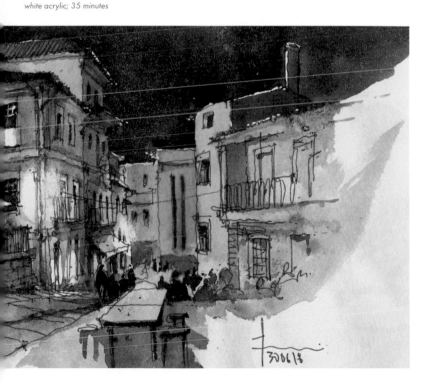

NEON

Neon offers a very specific challenge: it can be the brightest light in a view, but often that light is a very high chroma color. To get a high chroma red, for example, this usually means we want to use a pigment at full strength. The problem with doing this with neon is that the neon can appear much darker than it should be since a high chroma red is also dark in value. Suddenly, the values in the sketch are thrown off and instead of having the desired glow, the neon becomes harder to see. By paying attention to the balance of color and value, we can combat this in a few ways.

- It's all relative! Make the surroundings darker so the neon is lighter by comparison.
- Leave the neon itself white (or, add the white back in with gouache or white gel pen) and make the glow around the light the appropriate color.
- Add the color of the neon to surfaces being hit by the light, while leaving the light itself a bright white. It gives the viewer the impression that the light coming off the white object is that color. You can make an artistic decision on how much of that color to include, if you want to portray it as a huge, all-encompassing glow, or if the light only touches the closest objects.

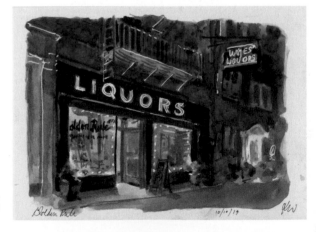

⊃ **KATIE WOODWARD**
Golden Rule Liquors,
New York City

*5" x 7" | 12.7 x 17.8 cm;
watercolor, graphite pencil,
white Signo gel pen, Pigma
Micron pen; 2 hours*

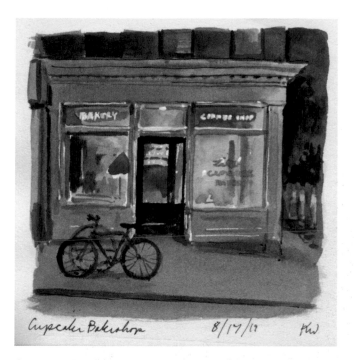

Ꙩ **KATIE WOODWARD**

Cupcake Bakeshop,
Brooklyn, New York

4" x 4" | 10.2 x 10.2 cm; watercolor, graphite
pencil, white Signo gel pen;
45 minutes

Ꙩ **KATIE WOODWARD**

Wonder Wheel,
Coney Island, New York

5" x 7" | 12.7 x 17.8 cm; watercolor,
graphite pencil, white Signo gel pen,
Pigma Micron pen; 1½ hours

Gallery: Neon

NY Hardcore Tattoos 10/1/19

☊ KATIE WOODWARD
NYHC Tattoos, New York City

5" x 7" | 12.7 x 17.8 cm; watercolor,
graphite pencil, white Signo gel pen

This awning was tricky, as it is catching light on the underside from the inside of the store, as well as from the neon on the window, while the top of the awning is also being lit by streetlights and ambient light. By giving the neon a tiny halo of its color and using pink and purple on the objects the light is hitting, it gives the impression of a tiny glow without being too much (especially since so much of the scene was being hit with ambient light and light from inside.) Note, too, the shadow of the awning supports visible as they are being backlit by the light from the window and door.

KATIE WOODWARD
Coolidge Corner Theatre,
Boston, Massachusetts

4" x 4" | 10.2 x 10.2 cm; watercolor,
graphite pencil, white Signo gel pen,
Pigma Micron pen; 30 minutes

Here, to create the look of blue and purple neon, I used white for the lettering and blue and pink to show the light emanating off the sign, obscuring the sky. Notice the lighter, more blue and purple color in the sky around the light, while the sky gets darker farther away, giving it a kind of corona.

KATIE WOODWARD
Reading Terminal Market,
Philadelphia, Pennsylvania

2" x 6" | 5 x 15.2 cm; watercolor,
graphite pencil, white Signo gel pen,
Pigma Micron pen; 30 minutes

In the case of this sign, taken out of context, I made sure to do the letters and neon in white, the surrounding area in the color of the neon, and used gray to make the neon color pop even more by comparison. Sketching it close-up gave me the opportunity to add in the dark sections of tubing connecting letters, which punctuates the bright neon.

SPECIAL LIGHTING

Lighting at a concert or sporting event can require a combination of techniques. The lighting may be bright white stadium lights, or bold, colorful theatrical lighting. We can use some of the same principals used for night sketching in these instances, but always want to start by locating where the light is coming from. We may see multiple light sources, with other parts of the scene falling into relative darkness. Often, we will observe one central area being lit.

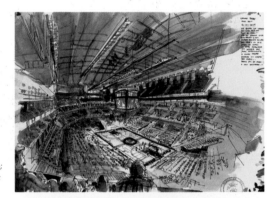

➲ **HUGO COSTA**
Nets vs Sixers,
Brooklyn, New York

11¾" x 16½" | 29.7 x 42 cm;
Rollerball pen and watercolor;
2 hours

➲ **KATIE WOODWARD**
Sunday Night Lights,
Brooklyn, New York

4" x 6" | 10.2 x 15.2 cm;
watercolor, white Signo gel pen,
Pigma Micron pen; 30 minutes

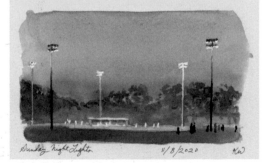

Observation Checklist

❏ Find each light source and see what direction it is pointed in.
❏ What color is each light source?
❏ Is ambient light hitting anything else in the scene? (Consider a staged play: the lights are focused on stage, but the first few rows of audience members may be visible as light from the stage bounces off and illuminates them.)
❏ Do you see multiple shadows coming off one object?